D0772204

Slate and Soft Stone Sculpture

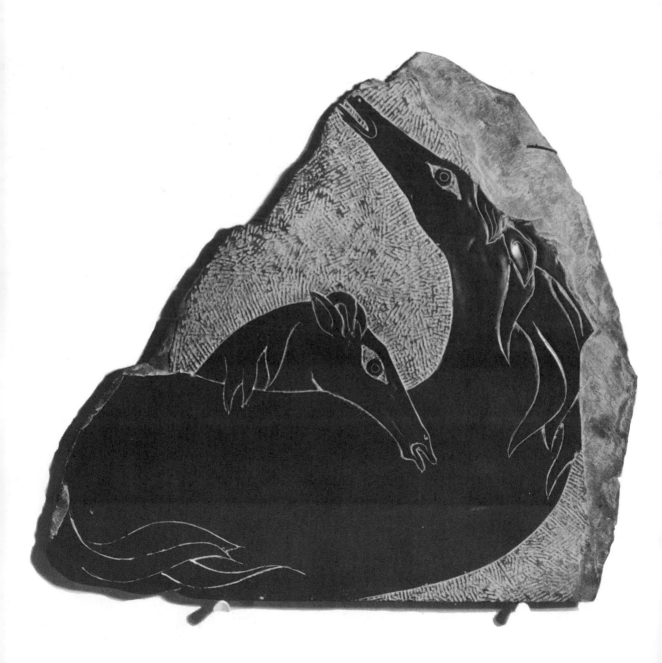

Slate and Soft Stone Sculpture

by Frank Eliscu

Photographs by David Rosenfeld

Chilton Book Company
Philadelphia · New York · London

First Edition
All Rights Reserved

Published in Philadelphia by Chilton Book Company
and simultaneously in Ontario, Canada,
by Thomas Nelson & Sons, Ltd.

Library of Congress Cataloging in Publication Data

Eliscu, Frank.
 Slate and soft stone sculpture.

 1. Slate sculpture. 2. Sculpture. I. Rosenfeld,
David, 1907- illus. II. Title.
NB1210.S55E44 731.4'63 72-4403
ISBN 0-8019-5643-9

Designed by Cypher Associates, Inc.
Manufactured in the United States of America

To my parents
who started me off
with a clean slate

Contents

Also by Frank Eliscu
Direct Wax Sculpture
Sculpture: Techniques in Clay, Wax, Slate

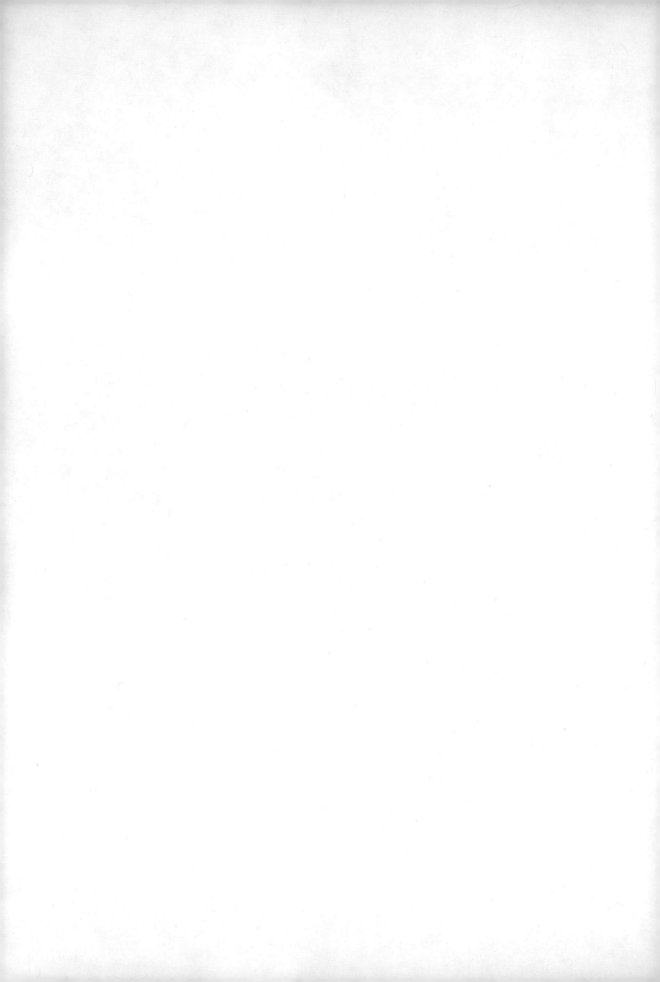

Slate
and
Soft Stone
Sculpture

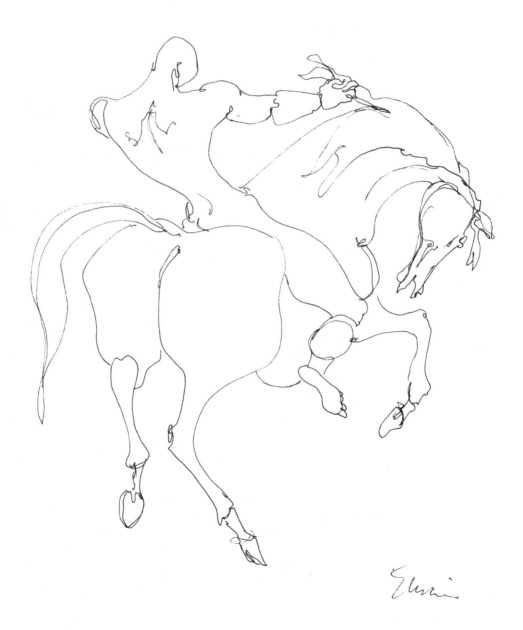

By Way of Acknowledgment

The picture of the struggling artist, lonely, beset by difficulty and despair, has become so familiar a stereotype that it is almost a cliché. Of course, there have been, and still are, those in the arts whose lives have been one disappointment after another, but the same is true of other fields as well.

As one whose whole life has been spent involved with art, specifically sculpture, I must confess that I am one of those who feels fortunate to have been able to do the work I love best. For not only has each day been filled with the excitement of solving the challenge of each new piece, but along the way I have gathered countless friends among fellow artists whose warmth and understanding have given a real dimension to my life.

In doing this book I have called upon some of those whose experience in their respective fields is outstanding.

It is not everyone who is fortunate enough to have friends with such warmth and generosity. May I say to all of you who have helped—you have made the book a delight to do. My heartfelt thanks.

To the Reader

When a sculptor starts working on a piece of stone, it is very like the beginning of a love affair. All the beauty is there in the stone waiting for the hands of the sculptor to bring it out—the feeling of excitement and the dedication to each other, the sculptor and the stone, and the certainty that this is the real thing (Oh, Pygmalion!).

The wonderful part of it all is that each new stone is a fresh and new experience—but with the same excitement and anticipation all over again. Perhaps that is why artists normally live longer lives. During the Renaissance, when man's share of time was considerably less than it is now, men like Titian, Michelangelo, Da Vinci, et al., lived on into their eighties. Many of my sculptor friends keep young by constantly working even into their seventies and eighties.

Just as the gold prospectors of the Old West were sure that they were going to find El Dorado or make the big strike each time they ventured out, so the sculptor feels that anticipation with each new piece. No two experiences can ever be the same, for creation is a new act at each rebirth. How can one ever grow old in these circumstances? Frustrated—yes; unhappy—possibly; but bored or jaded, *never!*

And so to you, who are about to embark on this journey into the world of slate and stone sculpture, good luck! A world of excitement and total commitment awaits you, for what you do in the stone will be your own personal statement to be seen and enjoyed for as long as stone endures.

HISTORY

Stone being one of man's oldest means of art expression and slate one of the more easily carved stones, it was quite natural that the early artisans found it suitable for recording the rites and rituals, as well as the story of their times. As each culture developed its art forms, it naturally used the materials indigenous to it, and so the Greeks, with their source of the beautiful Greek Pentelic marble, developed their style in marble. However, soft stone was also used, and a good example is *Youth and the Demon of Death*, an early fourth-century Greek statue now in the Archeological Museum of Florence. It is 47″ long and the local soft stone is called "Pietra Fetida."

The working in the softer stones, such as limestone and the steatites, are familiar to us, but the idea of slate as a sculptural medium seems surprising, perhaps because we have become so accustomed to seeing slate in the context of blackboard, floors, roofs and other such mundane forms.

The earliest slate carvings go back as far as the Egyptian dynasties, and the *Palette of King Narmer* in the Egyptian Museum in Cairo. It is a beautifully carved relief in as perfect condition as when it was first made in 3100 B.C.

The slate statue of *Mycerinus and His Queen* in the Boston Museum of Fine Arts is 56″ high and dates back to 2500 B.C. Illustrated are just a few examples, but they help to pinpoint the span of time that has encompassed the use of slate.

While there has never been an extensive use of slate as a sculptural medium, we do find it used in most unexpected places. Tombstones are made of it, for instance, and the rubbings of old slate tombstones are an art form in themselves.

The English sculptor, Eric Gill, used slate for some of his most exciting works. As England is a natural source of this stone, it was most natural that it became one of his favorite media.

There are other sculptors using slate; one that I know of, John Skelton, also in England, is a fine artist in this uncommon medium.

In this brief, historical glimpse I have attempted to give an artistic validity to a stone that most people think of in terms of blackboards, roofs and window sills.

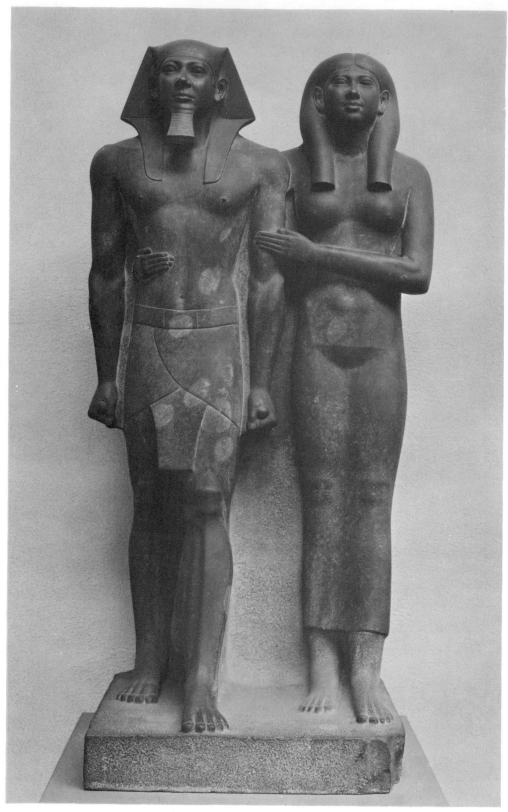

Mycerinus and His Queen. *Slate (front view), 4th dynasty. Courtesy, The Museum of Fine Arts, Boston. M. F. A. Expedition Fund.*

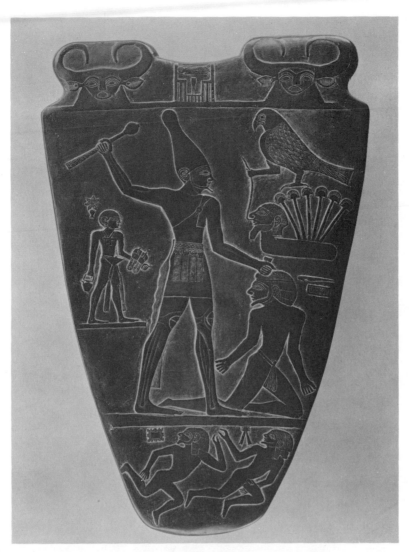

Antiquities-Egyptian Sculpture-Reproduction, II Dynasty, Palette of King Narmer. *Slate. Original found at Hierakonpolis, is now at the Cairo Museum. Courtesy, The Metropolitan Museum of Art, Dodge Fund, 1931.*

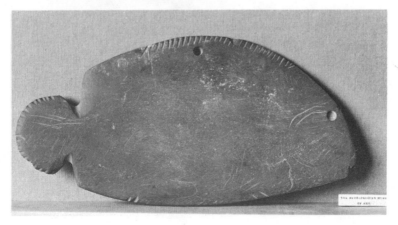

Antiquities-Egyptian, predynastic period. Palette: fish shape. *Slate. Courtesy, The Metropolitan Museum of Art, Rogers Fund, 1907.*

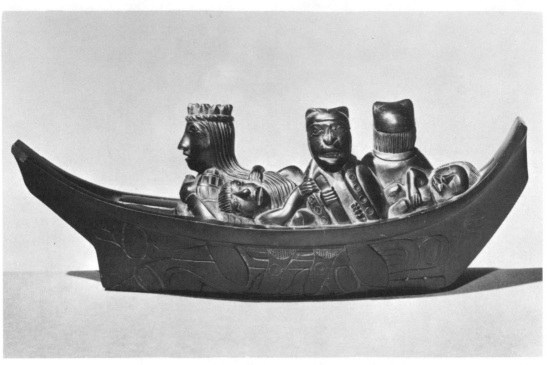

Canoe with Figures. *British Columbia: Haida. Slate, 13⅝" long. Courtesy, The Museum of Primitive Art, New York. Photograph by Charles Uht.*

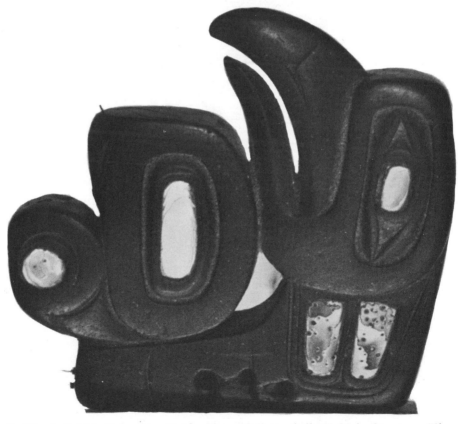

Bird's Head. *British Columbia: Haida. Slate, Naliotis shell, 3" high. Courtesy, The Museum of Primitive Art, New York. Photograph by Rudolf Burckhardt.*

STYLIZATION

The term, stylization, as used in sculpture, has a specific meaning. It means a conventionalization or, in other words, a means of portraying the object to be represented in a style of expression, rather than in the realistic appearance of nature.

All art, from every culture, has had its own stylizations. The frontality of Egyptian sculpture went so far as to predicate what could or could not be portrayed sculpturally.

The law of frontality is briefly that figures are all seated or standing with the weight equally divided. If a plumb line were to be dropped from the center of the forehead, the figure would in all cases be divided equally. Characteristically, the archaic Greeks showed heads with a slight smile; Indian sculpture is characterized by the smoothness and roundness of forms and an exaggerated narrowness of the waist.

I could go on and on and on with examples of stylization, but I am sure that you, the reader, can think of many other examples, so let us get to the importance and reason for stylizing a piece of sculpture.

In working slate relief, we are attempting to express in the simplest terms (for we do not have the plastic scope of clay or wax, or even blocks of stone) our personal statement. To render an animal, a figure, or anything in a completely realistic manner would be to make your contribution to art nothing more than a photograph in stone.

The measure of an artist is, I believe, a way of showing things we have seen (or even not seen) before in a new and exciting manner. This is done by simplification, exaggeration or some piece of personal technique that spells out your vision and retains all the necessary ingredients of good design and completion.

The artist who develops a highly personal stylization that becomes a point of recognition for his work achieves what all artists strive for—a style that is his (or her) signature.

I would like to show some simple stylizations that have evolved over the years in my slate work. These are not in any way intended as examples to be copied, or even taken as the last word in what can be done. Rather, they are an artist's personal searchings for his own truth, given in the hope that some light may be shed on the road to your own individual style.

9

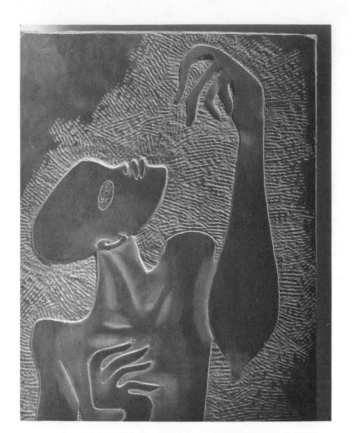

The treatment of both the hands and the eye are an example of simple stylization.

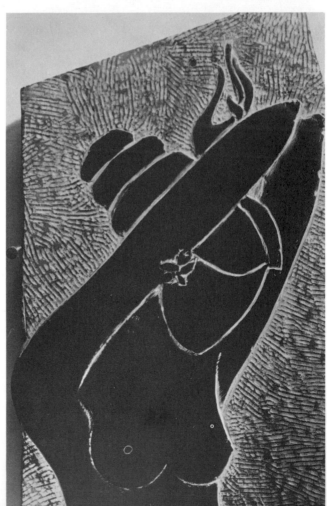

The elimination of features becomes a form of stylization in the head of the Balinese dancer.

10

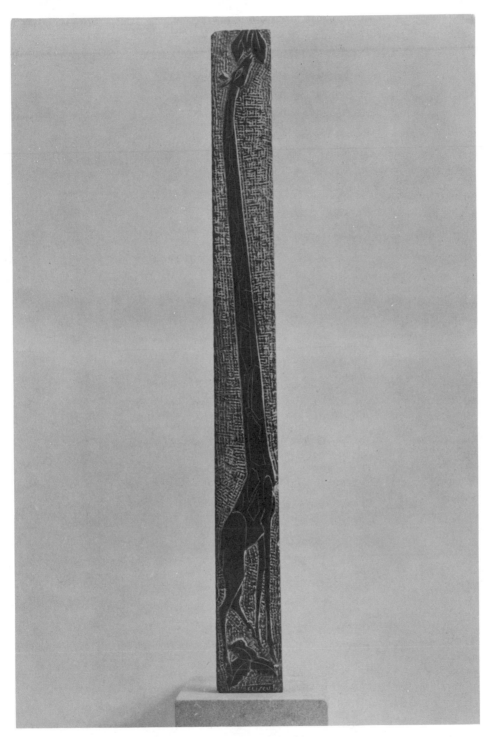

The essence of the giraffe is caught in the exaggeration of the neck.

11

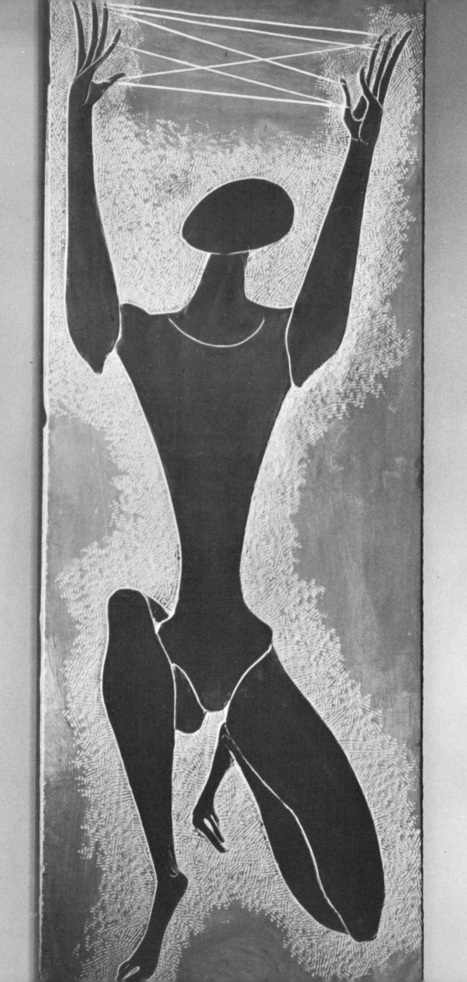

Balinese Dance. *Black slate, 10" x 30".*

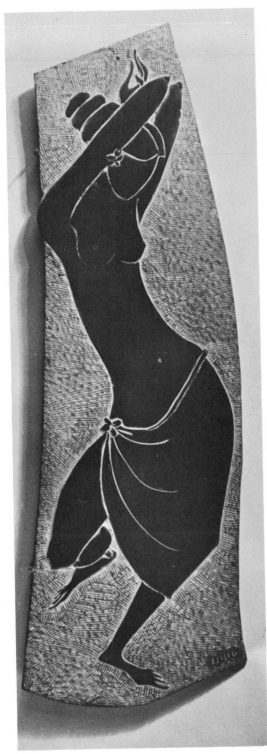

Bangkok Dancer. *Black slate, 12" x 36". Detail showing conventionalization of eye, hands and drapery.*

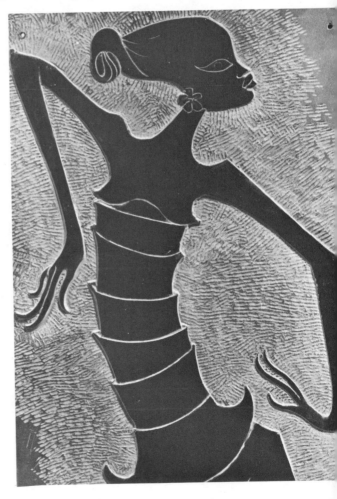

Cats Cradle. *Black slate, 15" x 36". The "cradle" is incised in the slate, then filled with white grout.*

13

The High Trapeze. *A study in arrangements, using a pair of slates.*

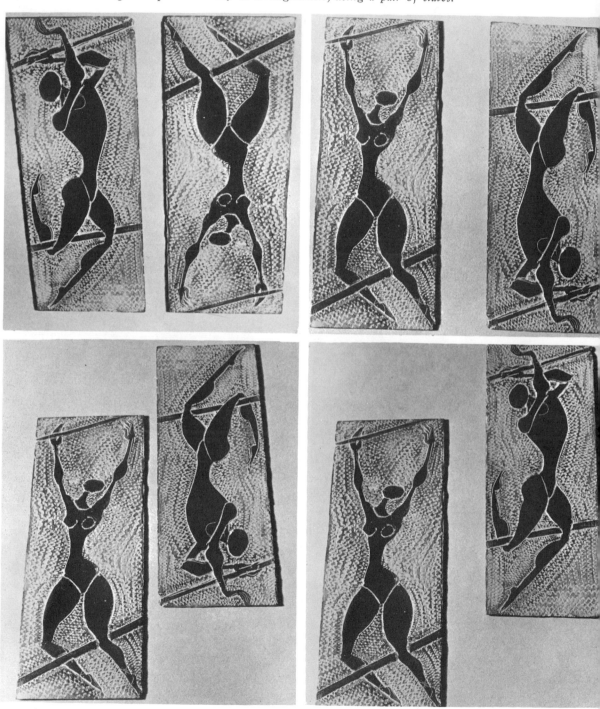

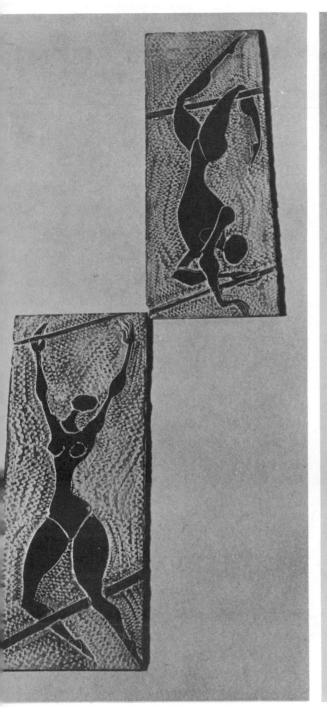

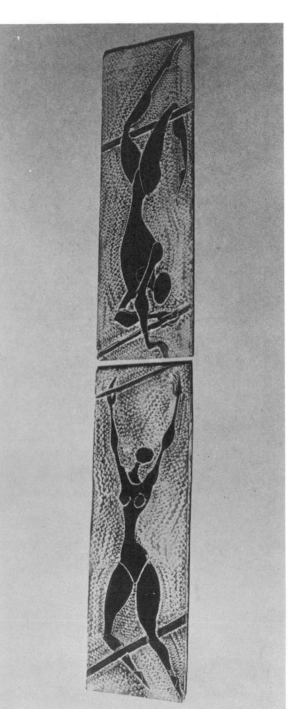

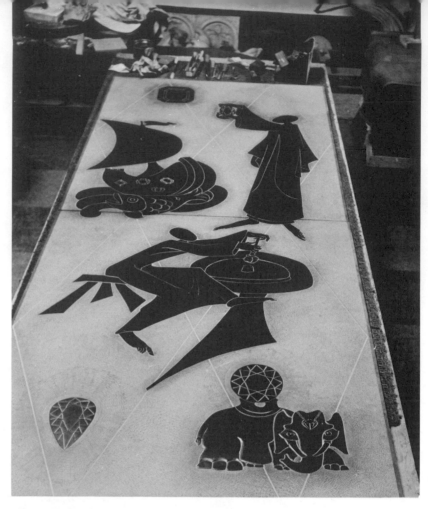

The World of Diamonds. *Slate door for the Diamond Center Building, New York City. Slate in studio, with tools, etc., on the table for final finishing prior to installation.*

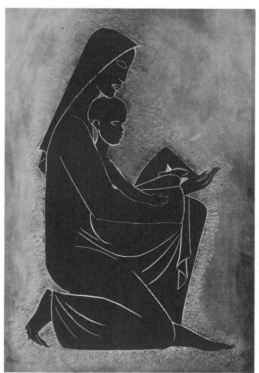

Mother and Child.
Black slate, 5' x 4'.

THE DRAWING

Preliminary to almost every work of visual art you will find a rough sketch or drawing of some kind. It is by this means that the artist will put his thoughts on paper and test the validity of his inspiration.

The sculptor, especially the worker in stone or wood, whose medium is not expendable (certainly less so than the painter or clay modeler), must be sure of his design before the first stroke of the chisel. This necessity for drawing has given the world some of its finest drawings. These drawings are by sculptors such as Rodin, Michelangelo, Da Vinci and Henry Moore.

Drawings by sculptors are usually distinctive and have a quality that makes them recognizable as the work of an artist dealing in mass and form as opposed to painters and graphic artists.

Painters, as a generalization (always open to exception, of course) are concerned with light and dark, and forms suggested or inferred, whereas the sculptor's primary concern is the delineation of form and mass, and his drawing attempts to use line as a means of enclosing form.

The line drawings of Picasso, for instance, have a distinctive sculptural quality which does not negate my premise about sculptor's vs. painter's drawings. For Picasso, as well as a goodly number of other great artists, has as strong a sculptural quality as most sculptors. I would say that Picasso's sculpture (as well as Michelangelo's paintings) prove that the sculptural quality of a drawing is a most distinctive and beautiful thing.

In making a drawing for a slate relief, one must keep in mind that the drawing must soon be transferred into form and so must have absolute definition, rather than a suggestion of form. In other words, the form must be stated.

Here is an example—a single line to suggest a strand of hair would do in painting—but not for sculpture.

The strand of hair must have at least enough substance so as to be delineated from a background.

I will try to show a sculptor's approach to drawing with a few illustrations that will I hope clarify through art that which may be inadequately stated verbally.

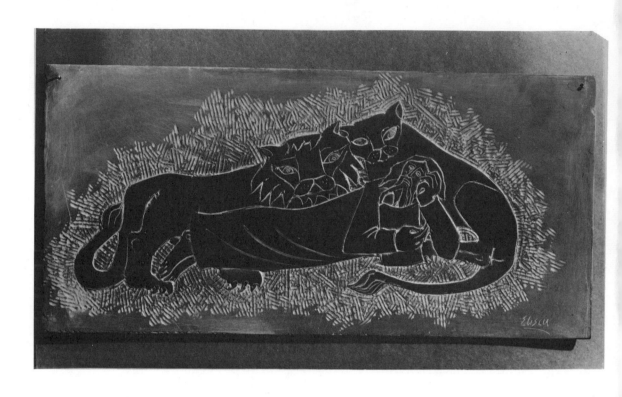

18

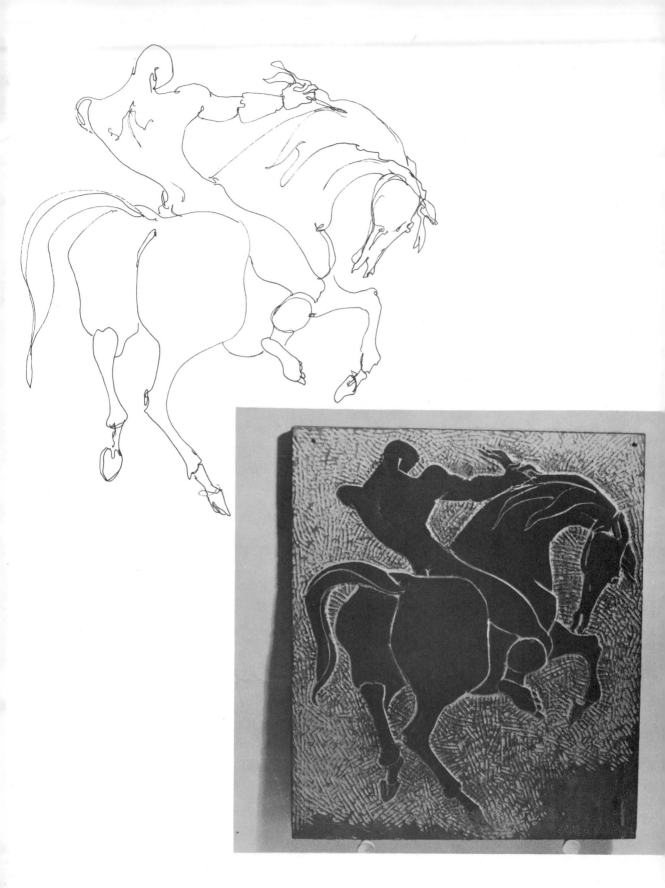

FROM THE TESTAMENT

If art tells a story, the one great source of all art is undoubtedly the Bible.

In earlier times, when art was the one mass medium of communication for the people, the church utilized artists to spread the story of religion. The Bible has given inspiration to more artists than any other single theme in the world.

The Middle Ages and the Renaissance produced great art by necessity rather than chance, for the one sure way that the people could know about the Bible stories was to see paintings and sculptures of the stories from the Testament.

With the rise of Christianity in the Western World, the preponderance of art, ecclesiastical, as well as other, derived its inspiration from the New Testament. Every church became a veritable museum, and the paintings and sculpture in the churches told the story of Christ. Outside the church, artists found the wealth of thematic material in the Old Testament as well, and from Michelangelo's great rendition of *Moses* to Cranach's *Eve*, we can see the range of interpretation that was possible in the Testament.

Before letters begin to pour in from observant readers of this book, let me state that I *know* that there were only four toes on Jonah's foot, and, in fact, on all of the Old Testament patriarchs you will find a finger or a toe or some part of the body missing.

This, dear reader, was not sheer laziness on my part, nor was it accidental. I have purposely left out these parts to conform with Orthodox Judaism. In the observance of that religion, any human being without the full complement of his anatomical parts is *not* in the image of God, and so is not in violation of the commandment; "Thou shalt not make a graven image." Incidentally, this is a feeling that only the most orthodox of today's religious groups follow. In truth, I have met a group of Chasidic Jews (a very orthodox sect) who were creating sculpture in Israel, and merely leaving off a finger, a toe, etc., to conform with Talmudic law, exactly as is shown in some of these slates.

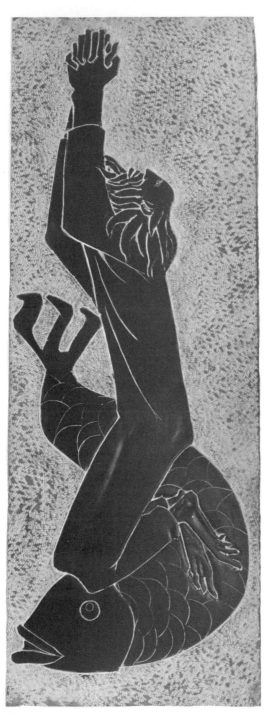

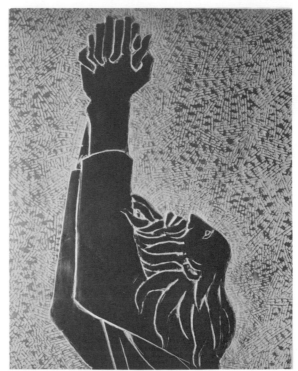

Details, Jonah.

Head of Jonah. *Black slate. Detail of* Jonah and the Big Fish.

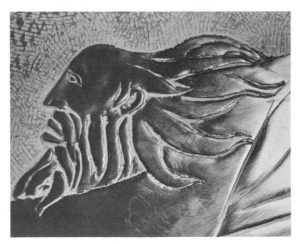

Jonah and the Big Fish. (*The fish's tail forms the Hebraic letter* ש, *which is used as the word for God.*)

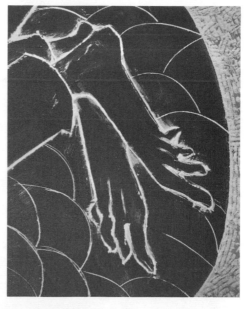

Detail of hands. Jonah and the Big Fish.

Detail of Jonah's feet (the text will explain the four toes).

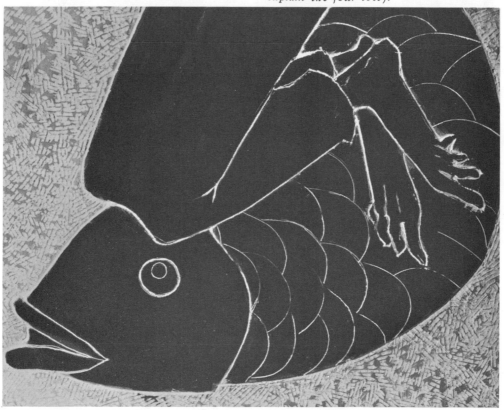

Detail from Jonah and the Big Fish. *The feet have only four toes. The text of the chapter explains why.*

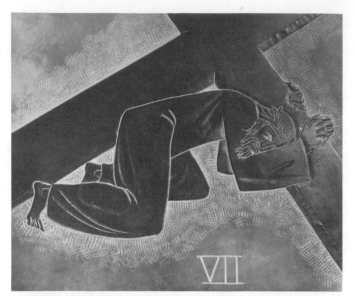

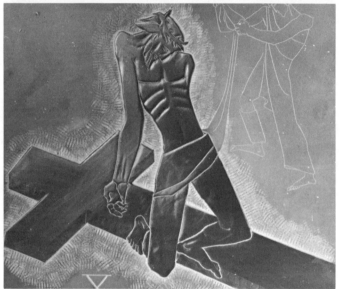

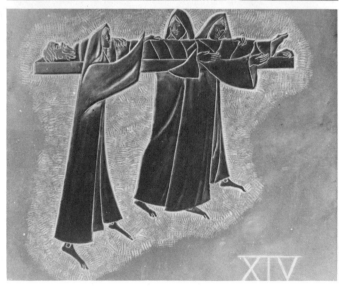

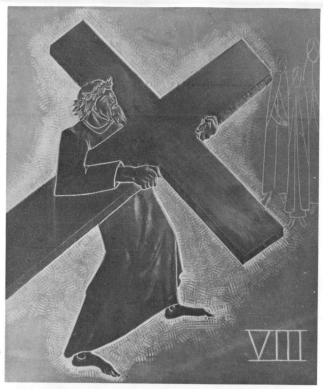

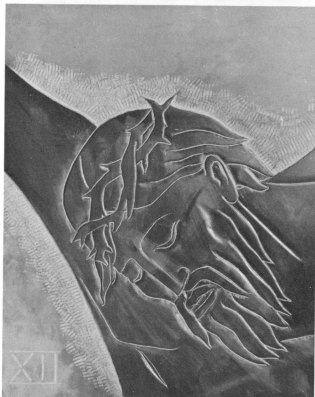

Six of the fourteen Stations of the Cross *made for the Father Judge Seminary,*
Lynchburg, Va.

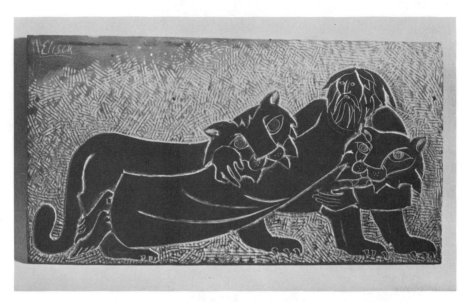

Daniel and the Lions. *Small model, black slate, 8" x 12". The eyes of the lion are gold leafed.*

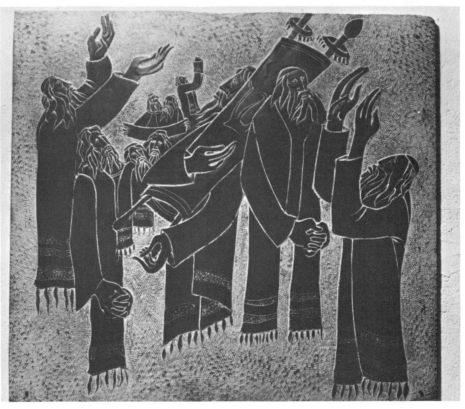

The Minyan. *This slate, 3' x 4', shows the traditional Hebrew ritual, which requires at least ten men for the daily prayer.*

26

MOTHER
AND CHILD

If the art of the civilized world can be said to have any one dominant theme, "Mother and Child" would have to take precedence over all others.

The Western cultures portrayed the Mother and Child subject as "The Madonna," and in the art of the Renaissance and the Middle Ages, this one theme came to its full flower.

Notwithstanding all the astounding advances man has made in the sciences, and despite our sophisticated culture, the miracle of birth still captures our imagination and no achievement in our world can equal the wonder and phenomenon of this act of nature. It is the one universal fact of all life, and so deserves to be immortalized in art by its symbolical image "Mother and Child."

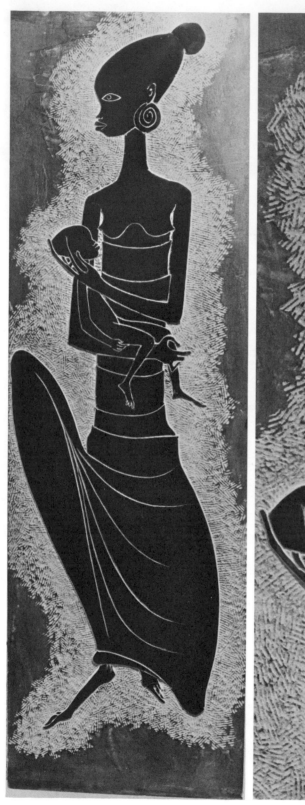

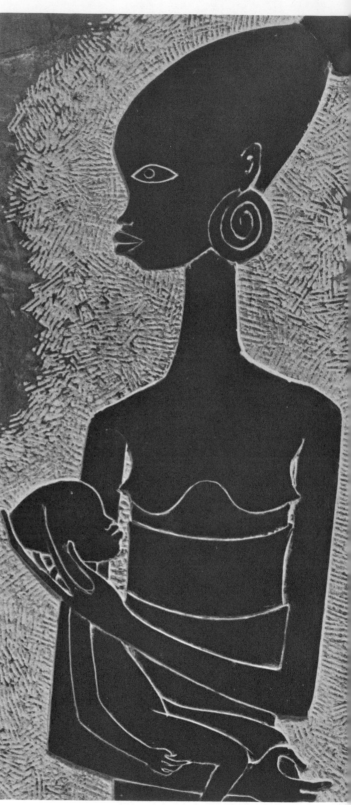

African Mother and Child. *Black Slate,* *12" x 36".*

African Mother and Child. *Detail.*

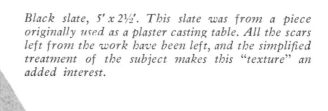

Black slate, 5′ x 2½′. This slate was from a piece originally used as a plaster casting table. All the scars left from the work have been left, and the simplified treatment of the subject makes this "texture" an added interest.

Mother and Child. *Black Slate, 5′ x 4′.*

THE NUDE

If art is the epitome of beauty, the human figure must be the symbol of all that is beautiful in mankind. The Golden Age of Greek art left us with examples of the beauty of the nude figure that have rarely, if ever, been equaled in any other period of time.

The beauty of the human figure, its symmetry, its free flow of form, the excitement of its design, has challenged artists from the very beginning of art, and will, I predict, do so until there is no longer any art. And that will be when man is no longer. For as long as man has feelings, and is capable of creative thinking, he will produce art.

There have been periods in the so-called civilized world when the appreciation of the human figure was in disgrace, but so basic is man's love of beauty that, in spite of all periods of repression, the nude figure has continued to be done in all the infinite variety of ways in which it appeared to the eyes of the artist, ever enchanted by the miracle of the human figure. The affinity of sensuous form and the free flow of its line make the female nude the most natural subject for slate relief.

These simple drawings will give a slight idea of how even a single line which suggests the nude body can carry the idea of the movement and sensuous grace that makes the human form a continual kaleidoscope of beauty. For with each change of action the forms rearrange themselves into new and lovelier forms.

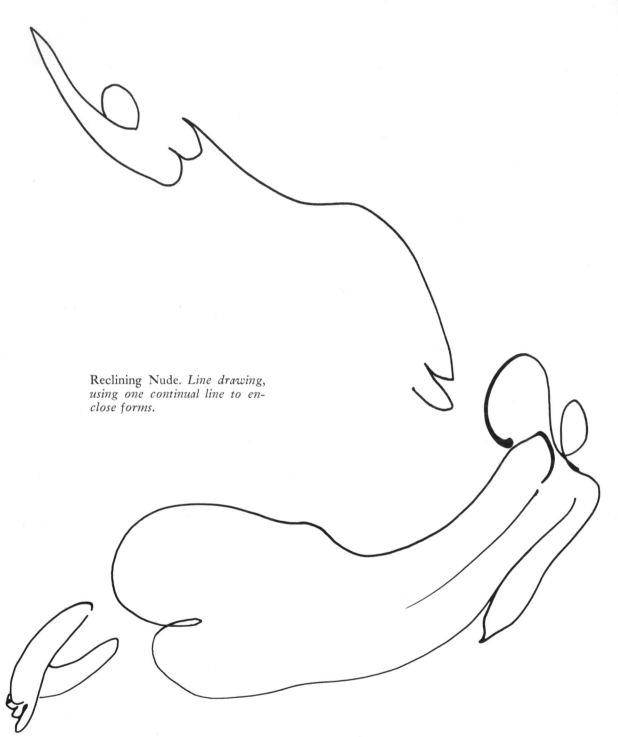

Reclining Nude. *Line drawing,
using one continual line to en-
close forms.*

Line drawing, Reclining Nude. *Sketch for slate, using line to enclose form and
volume.*

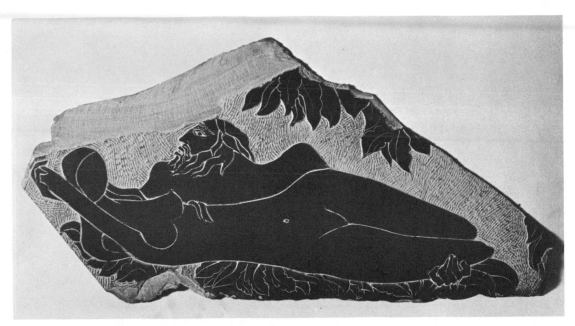

Satyr and Nymph. *A black slate fragment. 3' x 2'.*

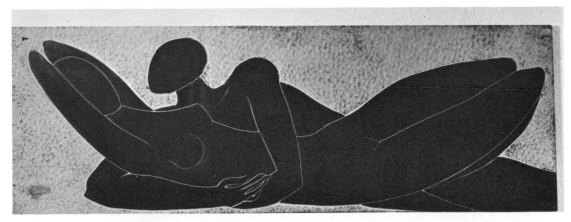

The Lovers. *Black slate, 5' x 18".*

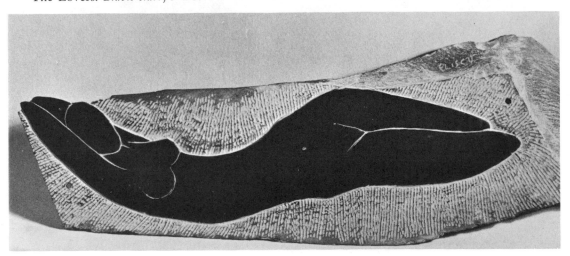

Reclining Nude. *30" long.*

33

A HERD OF HORSES

There is an old saying that "a dog is man's best friend," and that may be true. However, if the man is an artist, his favorite animal may be the horse.

The Greeks even combined horse and man to create the myth of the centaur, but the horse, per se, has been, and remains, a symbol of power, beauty and movement in one living form.

All through history the horse has played its role as the wings of man and, until the advent of the machine, this beautiful animal was man's foremost means of travel and power, and in many cases the sole means of survival.

Because of its affinity for man, the horse shares a major part of our history. In fact, every period of art has portrayed the horse in a manner indicative of the artistic level of the day, and every conceivable medium has been used for this immortalization.

The Greek "horsemen" from the west frieze of the Parthenon (one of our great sculptural heritages), have the typical beauty of the Golden Age of art.

The Renaissance gives us a different point of view in Leonardo Da Vinci's *Battle of Anghcari* (which we know only through his preliminary sketches), and in Paolo Uccello's *The Battle of San Romano* we have the horse as an extension of man on the battlefield, powerful, but done so beautifully as to become classic.

The Chinese clay horses found in the ancient graves from the Tang period are indicative of the great taste and high style of the period. Equally, the exquisite Persian miniature paintings and manuscript paintings show the pure lyrical design of the Near East.

And so, each culture has its own identity, from the vigor of Gericault's horses to the pastoral beauty of Rosa Bonheur's *The Horse Fair*. As the artist portrays the horse, he brings not only a picture of his time, but an evaluation of the art of his day. Now, apologetically, with this cursory background picture of the horse in art, here are a few examples of this splendid creature done in bas-relief slate.

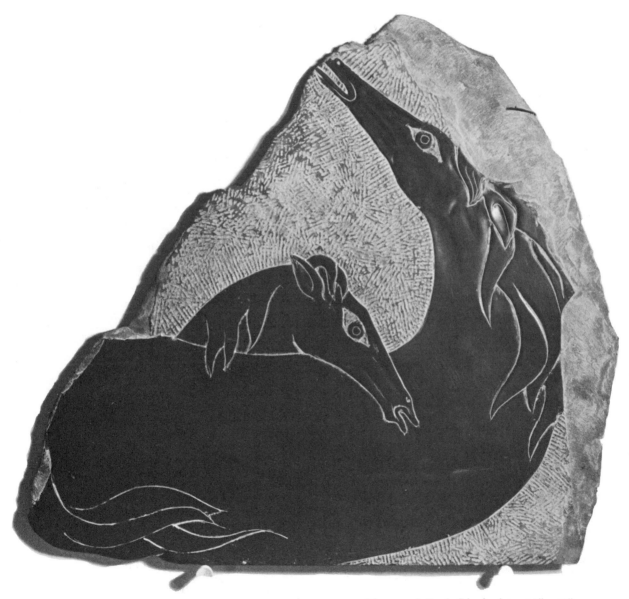

Mare and Foal. *Black slate, 15" x 15".*

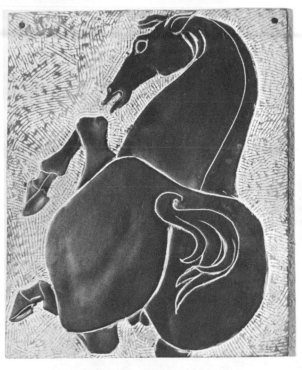

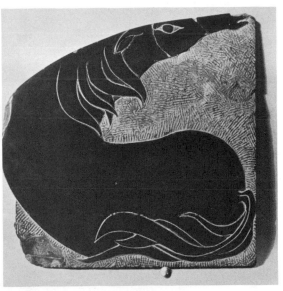

Renaissance Horse. *Black slate, 10" x 12".* Siberian Horse. *Black slate, 12" x 12".*

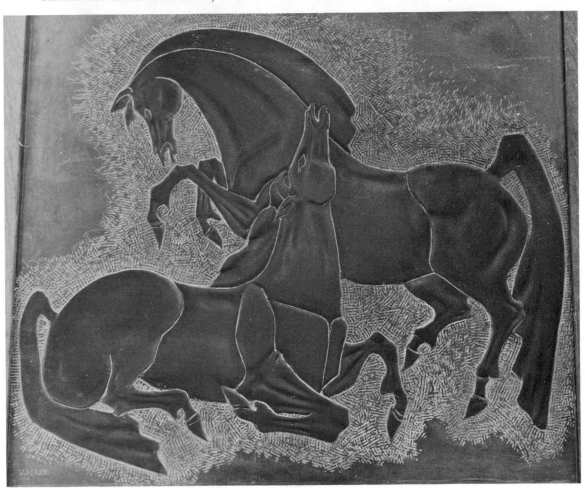

Horses. *Black slate, 15" x 18". Small model for the heroic horses, done in purple slate for the Bankers Trust Building, 529 Fifth Avenue, New York City.*

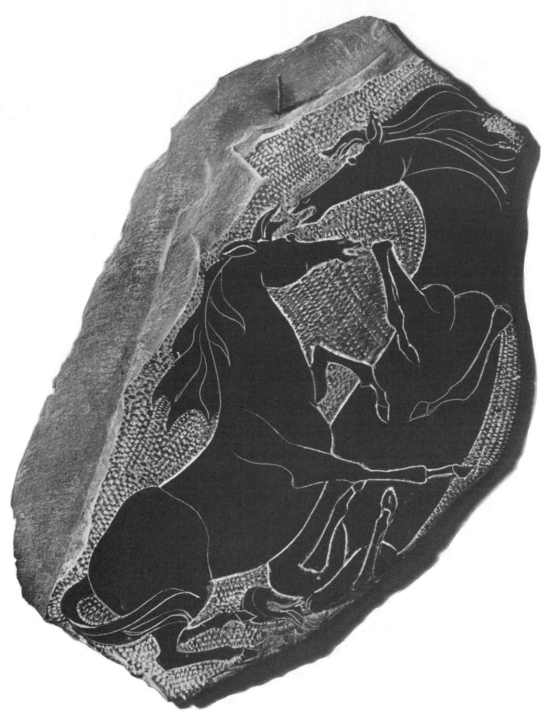

Fighting Stallions. *Black slate, 8" x 10".*

THE ANIMAL

From man's earliest recorded art, cave drawings, to our present-day art, the greatest source of inspiration and design for the artist has been the animal world. By animal world, we include birds, reptiles, insects, etc.— in fact, all living creatures other than man. In primitive cultures animals were gods to be worshiped, gods who took the form of birds, serpents, cats and even combinations of animal forms.

Some cultures combined beast and man (or woman) and produced such mind-shattering images as centaurs, mermaids, satyrs, or the Sphinx, and even Medusa, whose hair was a mass of snakes.

The sculpture of every culture from the primitive animals incised on the walls of the ancient Sahara caves to the beautifully executed serpentine stone carvings of the Eskimo Indians, still being done today, gives us a record of man's love for the beauty of animal form.

It would be easy to write pages and pages on the animal in art. In fact it has been done and overdone, so, rather than belabor the point, let us create a piece of sculpture using an animal as a theme.

This does not mean making a literal, photographic copy of an animal in sculpture; it means, rather, that we are to use its shape as an inspiration for design. The particular beast we will select for our slate is a bull, or to be more explicit, *Bull with Banderillas*. The bullfight, being a wonderful theme for the artist, gives him an opportunity to not only do a slate of an animal, but also to invest the animal with an emotional quality and, by thought association, we see not only the wounded bull, but also the entire spectacle of the bullfight.

There are some themes that capture the imagination more than others, and one of these is the bullfight, which is a part of the Spanish culture. Its essence of drama and the inferred violence combined with the entire mystique of the bullfight endow this theme with a strong sense of recall. Any one member of the cast in this drama brings the entire picture into focus. You have only to see the matador and you know that the bull is somewhere in the arena. By the same token, you see the bull, his head

thrown back and the banderillas piercing his neck and body, and the entire tragedy of what Ernest Hemingway so aptly called *Death in the Afternoon* flashes through your mind.

In this slate, the bull, slightly stylized, is shown wounded, his head thrown back in agony, the victim of the picadors' banderillas. If one picture is worth ten thousand words, then to take a picture and capture it in stone is to hold the moment forever.

In art the things that are not shown, but implied, are often more important than facts and forms that are obvious. As in most slate work, we start by doing numerous sketches, and when we find the sketch that seems most suitable, both in relationship of slate to the slate rectangle, as in this case, and style for slate work, we are ready to begin.

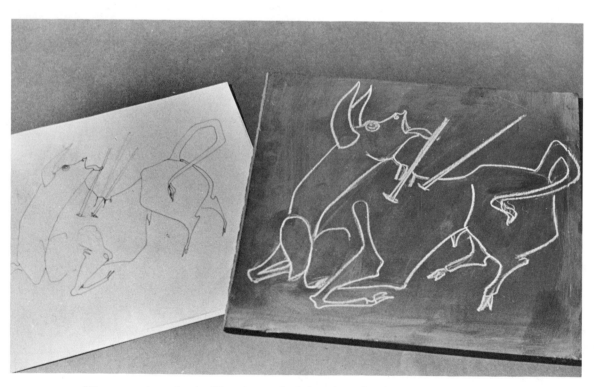

We are ready to begin. Here is our final drawing—the slate with our chalk version of the ink drawing. (Note the changes in the legs, etc.).

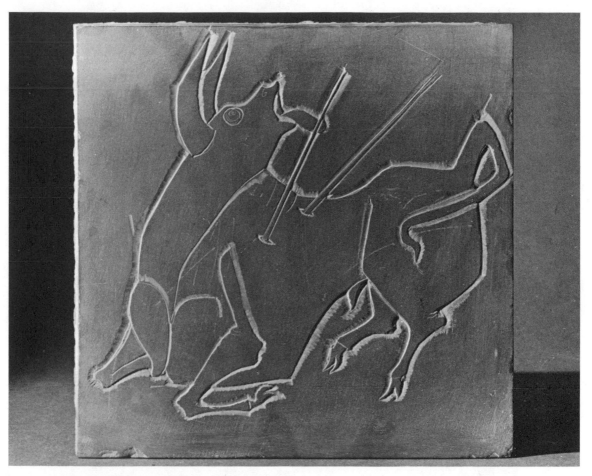

Having incised along the chalk drawing with a sharp, pointed tool, we now cut around the form with a chisel, so that it will be raised from the background.

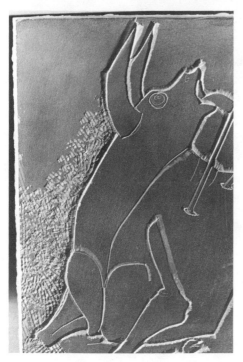

With our toothed chisel we next cut the background to separate the bull from the rest of the slate. This detail shows it quite clearly.

41

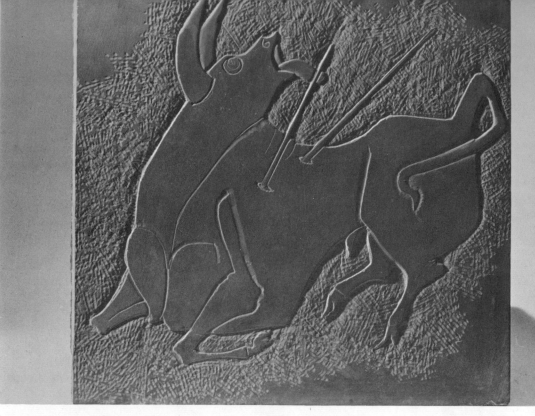

The background is cut—the slate now needs modeling with rasps.

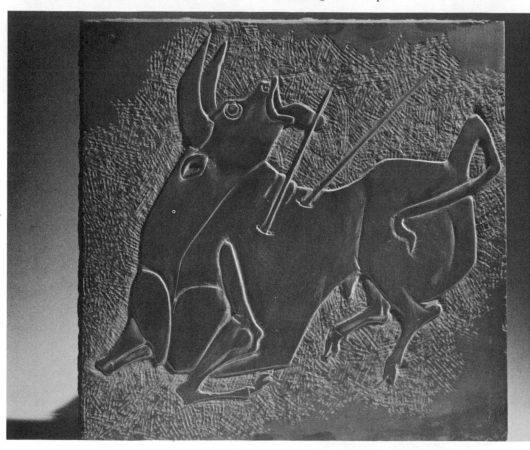

The ear is important only because of the subject matter. The slate would look as well without it, but the ear is an important symbol in the tradition of bullfighting. We accentuate the modeling of the forms with rasps, and then smooth the entire surface with sandpaper.

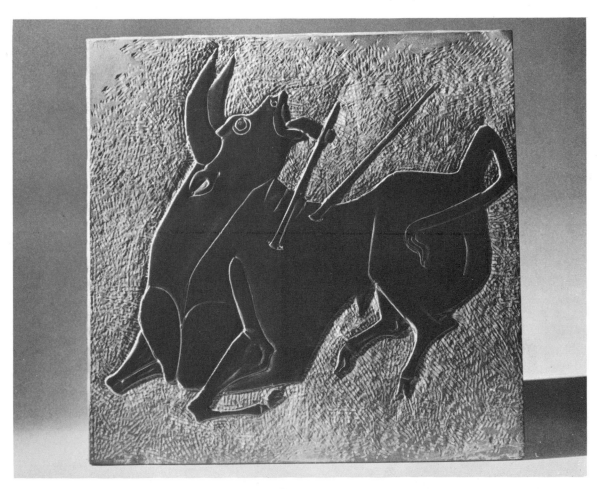

We are now ready to finish our bull—we wax the entire bull, and then buff it to shine. With a sharp tool re-define the lines lost in waxing.

BIRDS

Man has always been fascinated by birds. The grace of their flight and soaring and their beauty, as well as the mystery of their migratory and homing instincts, capture our imagination.

Every culture has paid homage to these creatures in one form or another. Ancient priests sought omens in the entrails of birds and today's astronauts are once again turning to birds for a solution of how they chart their courses during migration by the sun and the stars. The artists have always found birds a source of inspiration; from the sacred hawk of the Pharaohs to the great Audubon portfolios, their beauty is our heritage.

The infinite variety of birds—varied in size, shape and color as well as in species—all have the potential of challenging the artist's best creative instincts.

So, using "Birds" as a theme, we will try to illustrate the creative process by carving a bird in slate. While slate is a strongly disciplined medium that does not have the latitude of a facile medium such as wax or clay, it is still possible to capture the essence and feeling of a particular species of birds.

The preliminary thinking is every bit as important as the actual work in the stone itself. It is with this in mind that I include the sketch drawings and show the progression from thumbnail sketches to the finished slate.

In this slate, I must, as with all stone work, first take into consideration the shape of the stone I am to work with. This particular piece of slate is a rectangle, so all my thinking must be channeled toward a rectangular design. I will make dozens of quick sketches of birds and eventually select one that is pertinent to the shape of my slate. Then the drawing must be simplified, so as to be applicable for carving in slate, and here a sense of line drawing is very important.

The following drawings and photographs will now follow us through the creation of a slate called *Owls*.

The owl is one of the great sources of subject matter for an artist. He is not seen often enough to have become commonplace, and he can be delin-

eated with just a few lines which make him recognizable as an owl and nothing else. (Sketch I.)

From the famous Greek owl denoting wisdom to Picasso's bronze owl, and as far back as 1400 B.C. in the Chinese owl from Anyang, each artist has given an individual treatment to this universal bird.

Now let us see what slate will do for our owl, or is it what our owl will do for the slate!

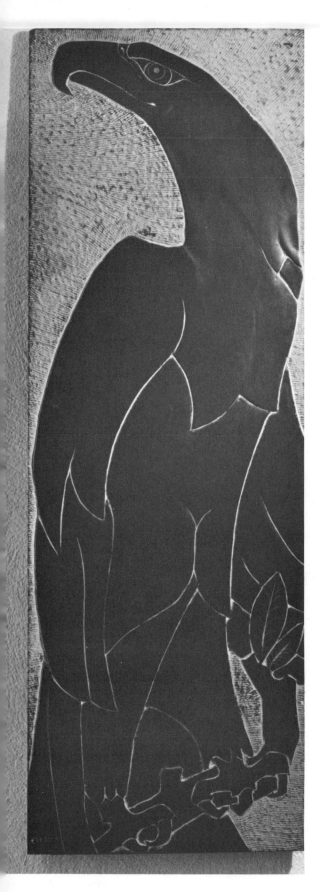

Eagle. *Black slate, 13" x 39".*
Gold leaf in the iris of the eye.

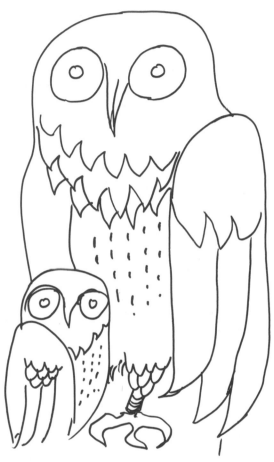

Final drawing for slate of Owls. Ready for transferring to slate.

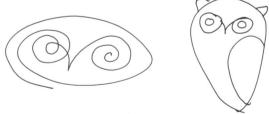

Simplified drawings to show the design elements for Owls.

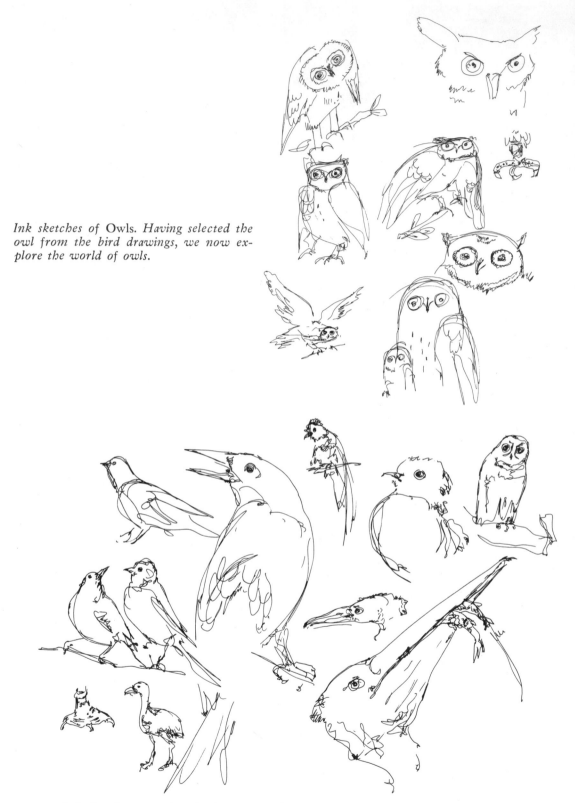

Ink sketches of Owls. Having selected the owl from the bird drawings, we now explore the world of owls.

Ink sketches of various birds. (In search of an idea for a slate.)

48

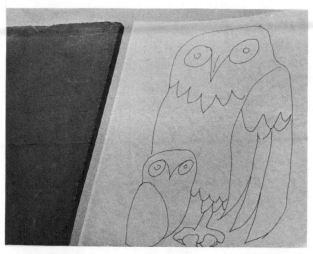

The simplified line drawing of Owls, and the piece of slate it will be carved in.

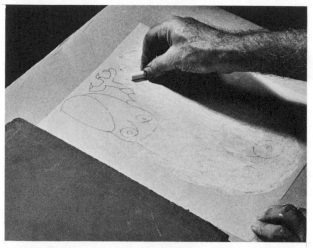

We chalk the back of the drawing so that we may transfer a chalk-line drawing from the paper to the slate.

The chalked drawing and the slate.

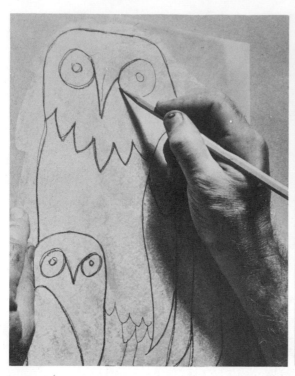

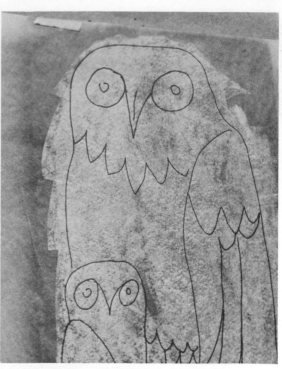

We re-trace our original drawing and so transfer the chalked back onto the slate under the drawing.

The drawing, chalked surface against the slate, placed on the slate and the ends taped to prevent the drawing from moving during the transfer.

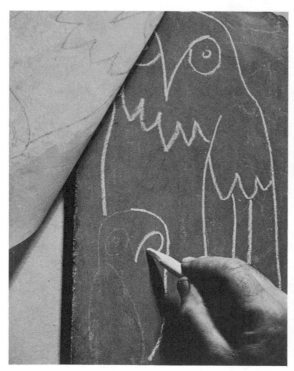

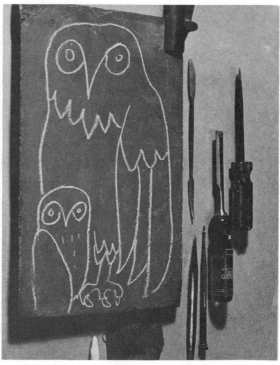

The chalk transfer will be faint—so re-trace on the slate with chalk.

We are now ready. A clamp holds the slate on the table. We will use a sharp tool for incising. It can be any pointed, sharp tool (scriber, ice pick, etc.).

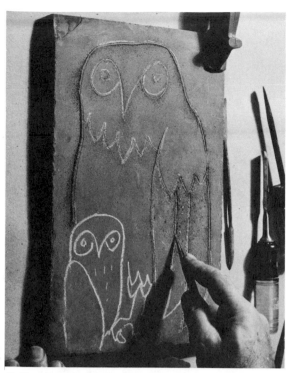

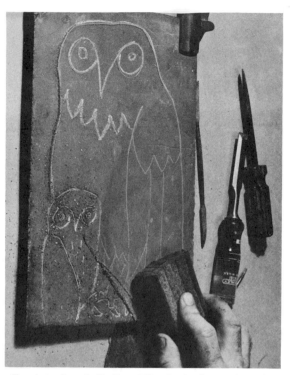

Following the chalk drawing, incise a line with a sharp scriber as deeply as you can—but making sure to follow the chalk line.

Erasing the chalk line. The incised cut should be a clean and firm line.

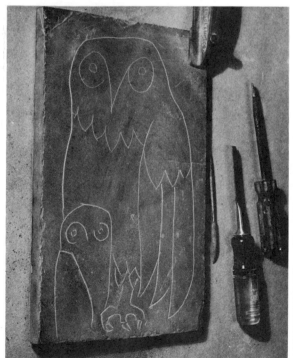

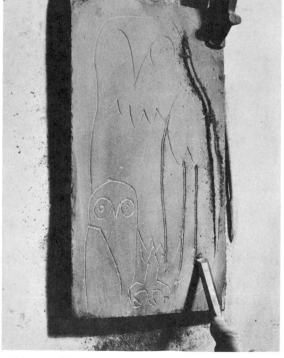

The incising finished. The slate dust wiped off, we can now see a slightly incised drawing on the slate.

Using a chisel, or even a sharpened screwdriver, cut along the incised line, the chisel biting into the surface to be lowered. The incised line should guide the chisel's path. We have now started a relief.

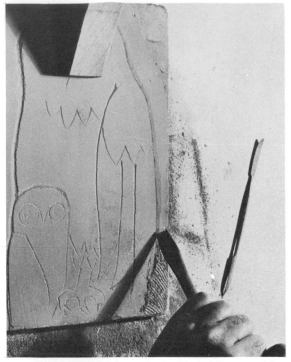

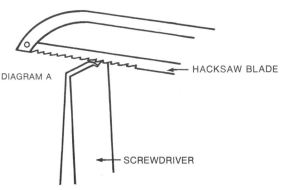

Using a background toothed chisel (diagram A), cut the background flat and thus raise the owls from the background. This will give a cross-hatched texture.

How to make a "background" tool: with a large screwdriver (½″) held firmly in a vise, make 4 notches, using a hacksaw blade.

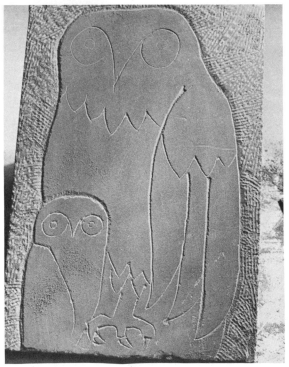

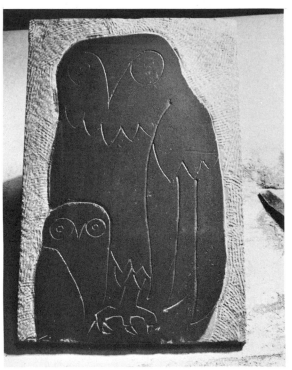

The textured background complete now contrasts the birds, and they start to "emerge" from the slate.

We wet the surface that eventually will be polished, and get an idea of what the slate will look like, when finished.

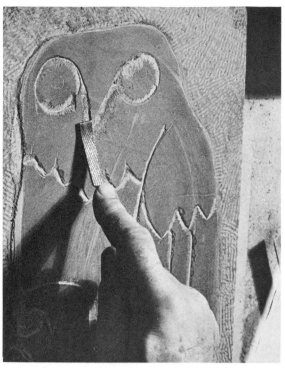

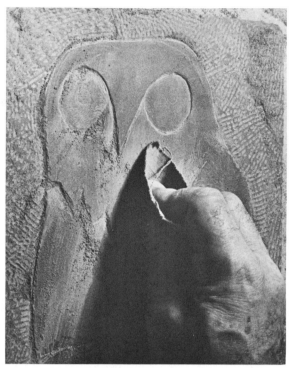

Now, using a rasp (a sort of shaped file), we bring out the high parts—the beak, for instance—by recessing the areas around them. This is the real modeling of the stone.

We now sandpaper the rasp areas smooth, enhancing the modeling, as well as eliminating the rasp marks. Emery cloth holds up better than sandpaper, but either can be used.

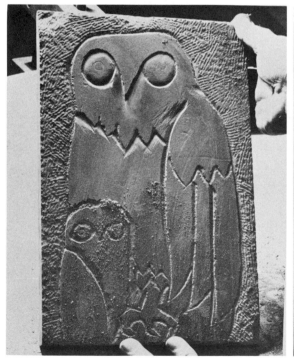

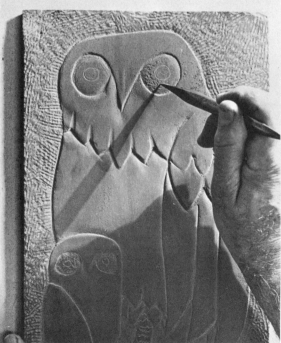

The owls with basic modeling started.

The modeling, with rasps, finished and sanded smooth. We now texture. Using our sharp incising tool, we stipple a texture in the eyes.

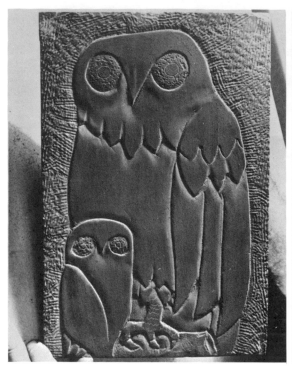

The slate is now finished, except for the polishing.

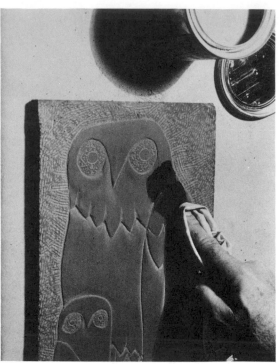

Polishing: using an ordinary, household floor wax, we carefully wax the carved owls, not the background.

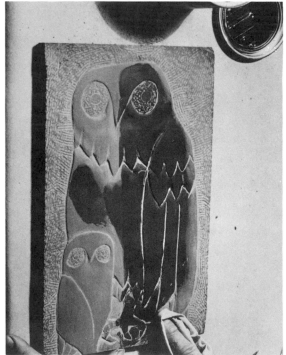

The slate darkens considerably where waxed.

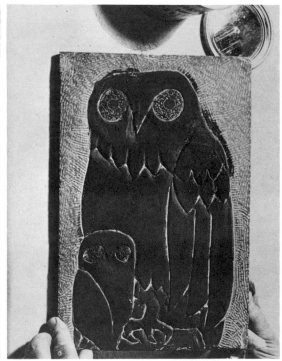

The slate is waxed, not yet buffed. Some of the wax has inadvertently bled onto the background.

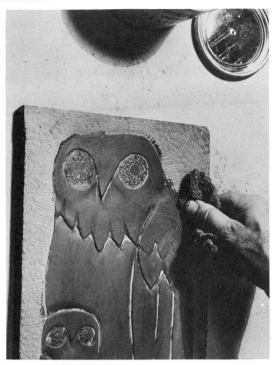

Steel wool removes the wax from the surface of the background.

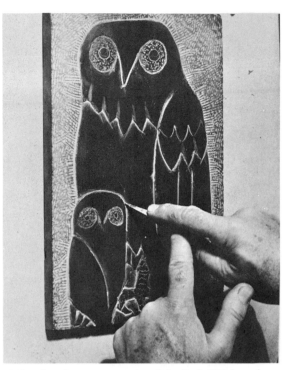

The slate is now waxed and buffed. With a sharp tool, remove the excess wax from the recessed lines.

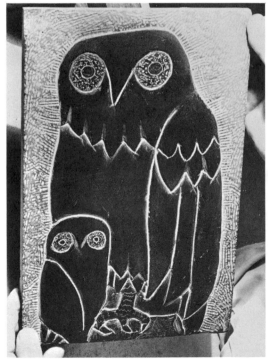

The slate has been polished, and is now finished— but it seems to need something to give it more punch or interest.

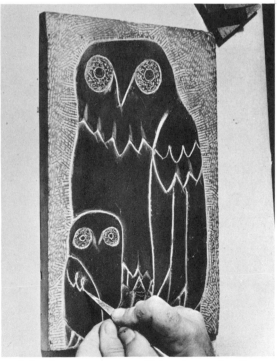

A feather treatment will break up the flat, uninteresting surface. So here goes!

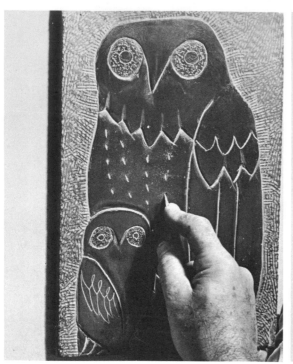 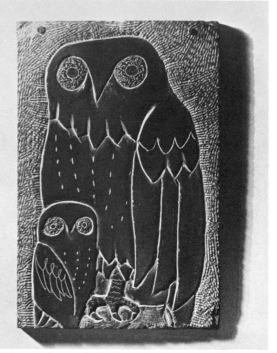

The feather treatment seems good, so we add a little design to the mother owl, hoping we are not now "gilding the lily."

Finished! So we drilled two holes, using any slow drill, or a hand brace and bit—and nail our slate upon a wall.

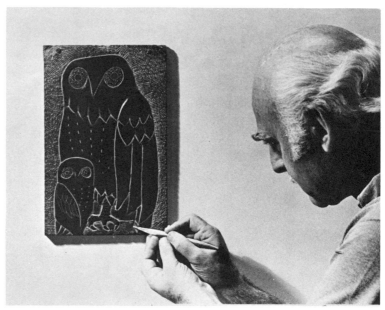

The final touch! Sign it.

SLATE SCULPTURE

The first piece of sculpture from the hands of man was probably the stone ax, roughly shaped to fulfill its basic purpose as a weapon. It is conceivable that when man hunted in a pack, as part of a clan or a group, he individualized the shape of his particular stone ax, and so gave himself an identity.

Time has brought countless changes and a sense of history since the world of the cave man, but the unyielding stone still holds the same fascination for man. And in its shaping we can still feel the urge to free the latent beauty inherent in the stone and so leave our imprint, our own sense of identity.

With all the world has gone through in time, man is still carving in stone. To the sculptor, stone is a cosmic force crying for form and the blows of the chisel to free the ideas imprisoned in the stone that until then were locked away.

The feeling for stone is as basic in man as his love of the water or the earth or the sky. And to one who has this special feeling, the very textures and colorings of stone are as beautiful as the sounds of music.

Unlike the working of clay, wax, or other malleable media of sculpture, the worker in stone enters into a commitment with his first strokes of the chisel. In the creation of any work of art the disciplines of technique set up a constant battle in which the artist's mastery of his medium allows him to express his ideas.

Without complete control of his material the artist cannot fully express himself. And, of all the media in the arts, stone is probably the most implacable.

In the passage of time the world has changed, but man has not. His basic feelings, his pride of accomplishment, his frustrations, the joy of creation —they are all still here. And so today we can still look at a stone that was here on earth before man and try to free an idea of our own—still imprisoned—and leave our own little imprint on time. When it works, it is a wonderful feeling!

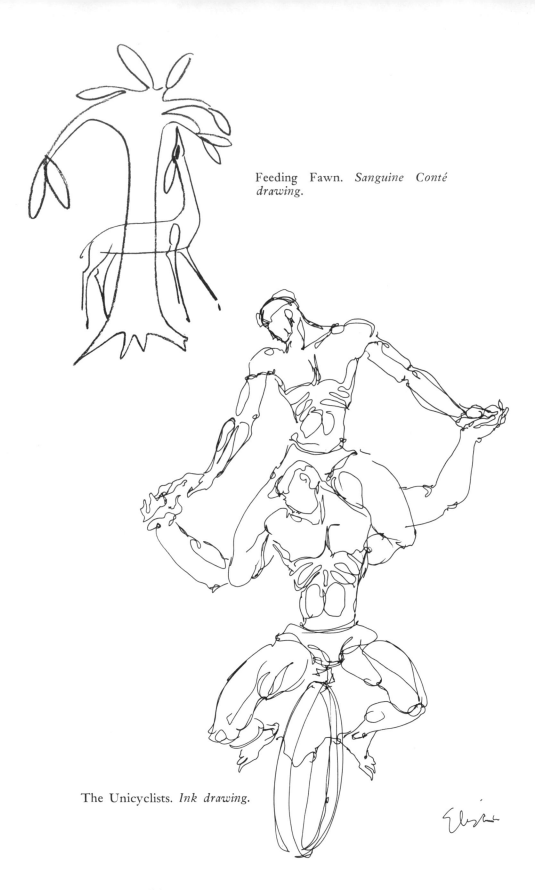

Feeding Fawn. *Sanguine Conté drawing*.

The Unicyclists. *Ink drawing*.

58

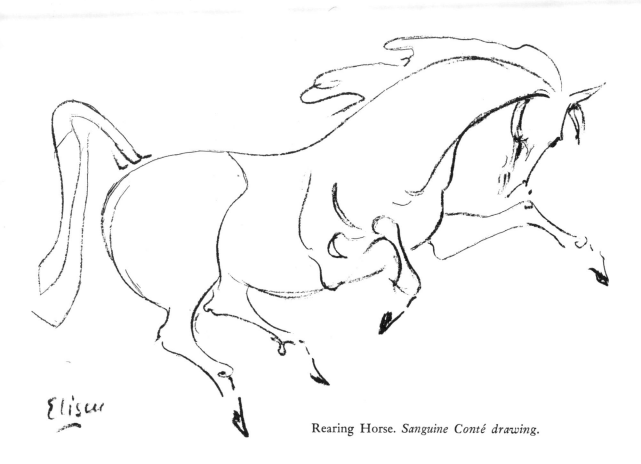

Elisco

Rearing Horse. *Sanguine Conté drawing.*

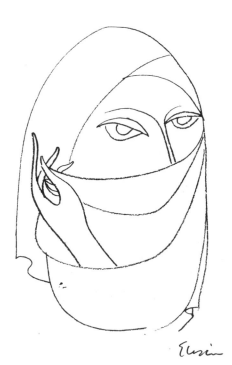

Drawing for slate. (Used in chapter on texture—a red slate.)

Elesin

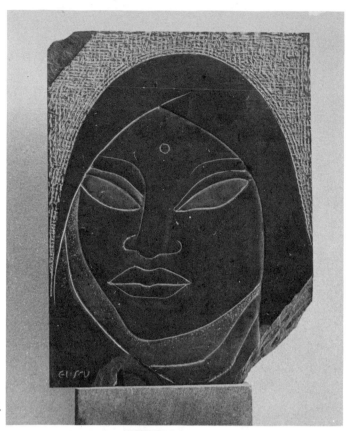

Head. *Green slate, 10" x 12".*

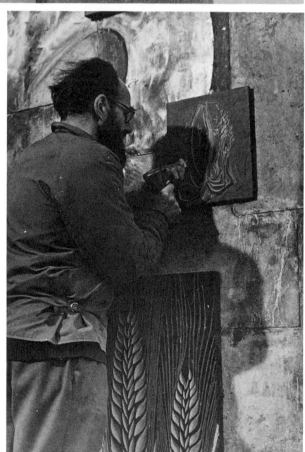

Sculptor John Skelton, A.R.B.S., F.R.S.A., at work in his studio in England.

60

SLATE: THE MEDIUM

The dictionary defines slate in both a technical and simplified definition. Simplified, it merely says: *a thin piece or layer of rectangular rock.*

In its more technical and exact definition it goes on: *a dense, fine-grained rock produced by the compression (metamorphism) of clays, shales, and certain other rocks so as to develop a characteristic cleavage (slaty cleavage) which may be at any angle with the original bedding plain. The minerals of the original sediment have been considerably metamorphosed and now consist essentially of sericite and quartz. The principal accessories are biotite, chlorite and hematite and minor accessories are magnetite, apatite, kaolin, andalusite, rutile, pyrite, graphite, feldspar, zircon, tourmaline and carbonaceous matter. Loosely, any cleavable rock resembling true slate.*

After reading this (for a nongeologist) almost incomprehensible definition, I went to a simplified book on the earth's make-up by K. F. Mather and found: *slate is a metamorphic rock resulting from the alteration of shale.* Having read all these definitions and some others, all along the same lines, I think that an explanation of slate from a sculptor's viewpoint, in simple language, gleaned from the experiences of working in this medium through the years, would be more valid and give us a better picture of slate to be used for sculpture.

To begin with, I started many years ago with an old, broken and discarded blackboard. In illustrating a point of drawing on the slate, instead of using a piece of chalk (which I didn't have handy), I scratched the drawing on the piece of blackboard. It didn't matter too much that the slate blackboard would be ruined; it was a broken piece to begin with and supposedly useless. I found that it was extremely simple to scribe or cut into the slate surface. Surprisingly, the quality of the line drawing was very pleasing. I did nothing more with the slate at that time. However, some days later I was trying to explain to some students how to "raise" a surface by cutting back from a flat area and I remembered the piece of blackboard with the drawing scratched in. So, using a screwdriver, I tried

to explain, thinking it would be only a verbal demonstration, with the screwdriver showing the angle and direction of the cutting. To my surprise the slate cut so easily and beautifully that within a matter of minutes the original drawing began to be a shallow relief. One never knows what little accident will open up a new vista. I think that is the fascination of the arts—there's always a surprise waiting, especially when we least expect it.

Slate (that is, the blackboards we are all familiar with) is a smooth, technically called "honed finish," soft rock. It has no grain to speak of, as for instance in marble. It has a laminated, or "layer" quality, but this rarely interferes with the carving. And, contrary to what people think, it almost never separates. I would compare it with layers of wood as laminated by cabinetmakers, who use glues, etc., and press the large pieces together to make one large piece of wood. Then the carving can take place, as with a single block.

The colors of slate are not brilliant, but are usually of an even, solid color, predominantly black, as used for the blackboards, and in reds. The so-called purple slate is a chocolate-purple, and the green is a soft grey-green. We have seen all these colors on the roofs of houses that still have slate roofs.

Naturally, there are gradations of these colors and often mixtures, the purple and green being very common.

Slate is quarried, as is marble, granite, etc., but usually in sheets rather than in blocks. The easiest way to get the slate is to cut it along its cleavage (or laminated) layer. It separates into large pieces quite easily.

Most of the slate in this country comes from Vermont, Pennsylvania and New Hampshire. There are other quarries in places like Virginia, Maine and possibly other states, but I do not know just where. I could not, for instance, get slate in California (local slate, that is) when I was doing a slate carving for a building out there.

In other parts of the world slate is known, used and cherished as both a structural and an art medium. And (indicated here in the historical part of slate), as an art form, we can see it was used as far back as 3200 B.C. in Egypt.

Slate can be cut with a hacksaw, carved with a simple wood-carving tool, even such makeshift tools as a screwdriver, an ice pick, or even a

sharpened nail. It can be given a surface smoothing with sandpaper, and for the modeling, stone or wood rasps are all that are necessary.

Yet with its apparent even softness (a carver's delight), slate can withstand the ravages of time far better than marble. There are evidences of this all over the world in the slate tombstones of early America, as well as in the slate roofs of the English manor houses.

I have given a brief sketch of what slate is like, but it is only when working with it that one can really get the feel of slate. Perhaps the rapport between you and the medium will be different from mine.

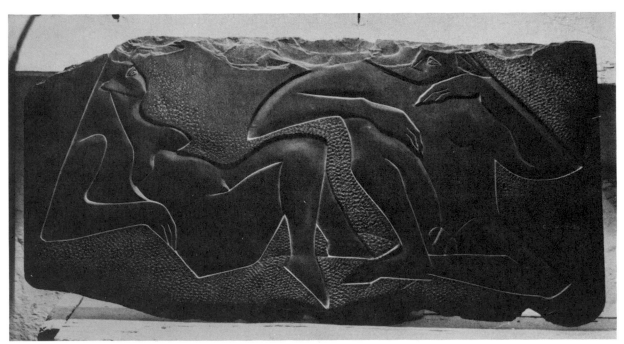

The Lovers, *by Claudia Widdiss. Black slate, 4' x 2'.*

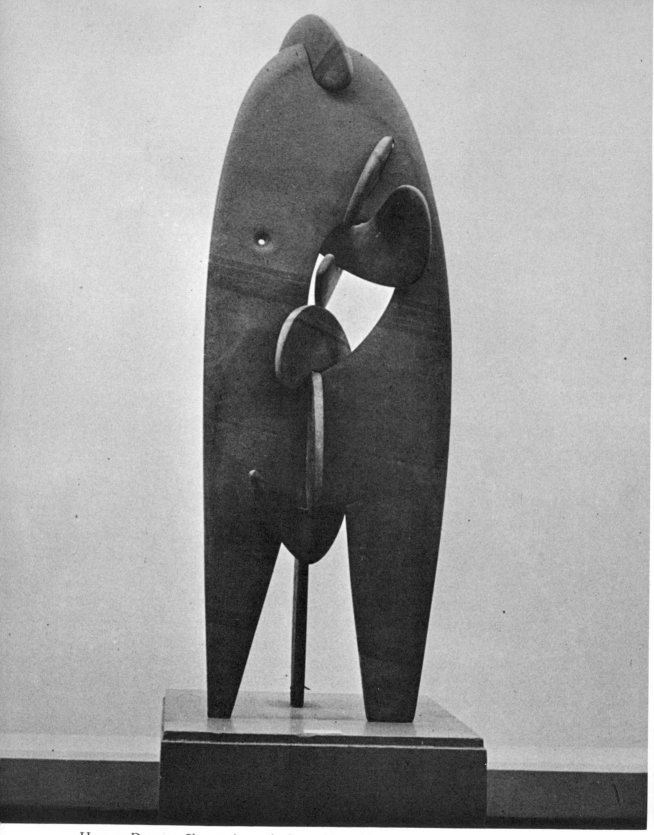

Humpty Dumpty. *Slate sculpture by Isamu Noguchi, contemporary American sculptor.*

SOURCE OF SLATE
AND SOFT STONES
FOR SCULPTURE

Very often the greatest barrier in starting a piece of stone sculpture is finding a suitable piece of stone to work with. Tools can be improvised. A household hammer (if no stone hammer is available), cold chisels from the local hardware store, wood rasps and sandpaper that can be purchased in any town or village, and any sturdy table with a large clamp to hold your work firmly (if you are doing a flat slate) put you in business—except for the stone.

The best slate for flat-relief carving is the kind that is used in schools for blackboards. This slate is black, has a smooth-honed finish, and is usually about ¼″ to ⅜″ in thickness.

For a source of supply, one of the best possibilities is the custodian of the local school. Contact him and ask if any broken blackboards are being stored in his cellar. If not in his school, he may know a fellow-custodial worker who does have some.

Another more normal source of slate for carving is the store that sells children's blackboards. These come with simple frames and usually are inexpensive. I have seen this type in sizes from 3″ x 5″ up to large 2′ x 3′. The smaller slates are no more than ⅛″ thick, and must be handled very carefully.

So far, the slate we've talked about is the beautifully finished "chalk" slate; the other, more readily available, is the kind found in building-supply houses. These are the slates used for walks or flagstone terraces and are thicker, generally ½″ to 1″ thick, and are called natural cleft. That is to say, not honed or polished, which means that you must sand or file down where you want a smooth surface.

The advantage of this type of slate is that it comes in good red, purple or green colors as well as black.

The piece of slate, when bought this way costs very little and, if you look around the slate yard, you can often find broken slivers or shards that the foreman is glad to give away. These often turn out most interesting because of the unusual shapes.

For the more ambitious sculptor, there is, of course, a more professional approach. Slate is handled by many large stone and marble companies. In the execution of large architectural commissions, I have ordered slate from the very large stone companies and could be sure of getting exactly what I ordered, in size, color and finish. In the slate *Horses*, shown elsewhere in this book, I needed ten pieces, each 5' by 2', purple in color, with touches of green to go with the marble (Renfrew) in the rest of the lobby. I ordered eleven pieces, one extra as insurance in case I broke or hit a flaw in one, and I wanted natural cleft for the background. I used Domestic Stone Company, in New York City, a very large and extremely fine stone company. However, there are similar companies all over the country. Just look under "Stone" in the classified pages, or ask the local monument and tombstone artisan in your neighborhood.

Now, for the soft stones and, as they are more widely known as sculptural media, I shall list where they can be bought under sources of materials later in the book.

I have included this part about slate because usually the average sculptural supply shop cannot help you, for slate is not seen too often as sculpture.

SLATE: FOR THE PRACTICING SCULPTOR

In the section, "Slate: the Medium," I have given a very brief and elementary picture of a subject that could, in fact, occupy the major part of a book.

The average sculptor has no more need of knowing the fissionability or cleavage of slate, than knowing, for instance, the 85–5–5–5 formula for bronze (the proportion of copper, and the other three materials, zinc, tin and lead, used by the bronze foundry in making your bronze cast).

The practicing sculptor should, however, have a working knowledge of the basics of his medium. I shall try to give the salient points that are necessary in ordering slate, and enough knowledge to talk intelligently to the architect whose province this really is.

There are two material gradings known as "clear stock" and "ribbon stock." The "ribbon" has veinings, which do not affect its strength, and "clear," as its name implies, is all one shade or color. This is the type used for making blackboards. The finishes of slate are most important for the sculptor to know.

The slate can be split into practically any thickness. It then has a "split-face surface," the surface left as a result of the first cleaning or splitting at the mill and before going to the planing machine. (In dealing with suppliers or architects, I have used the term "natural cleft"; it's the same thing.) Planed surface is almost the same as split-face, but without the rough characteristics. The plane marks are faintly indicated.

Sand-rubbed finish means that after planing the face is smoothed by sand and water on large, revolving metal disks. The result is a uniform, smooth surface with a grain or stipple. "Honed finish" is much smoother than sand rubbed and is the nearest thing to an actual polish.

Color is another important consideration, and for the sculptor whose work may be commissioned for outdoors there is an obligation to know the effects of the elements on his medium. The basic slate colors are:

Black	Grey	Purple	Green	Purple and green
Blue-Black	Blue-Grey	Mottled	Red	

These colors are all classified as either "unfading" or "permanent," and "weathering" slates. The terms are self-explanatory. The unfading, or permanent, have a minimal change and weather well. The areas these come from may be of interest to the sculptor:

Blue-Grey: Pennsylvania, Northampton County.
Blue-Grey: Virginia, Buckingham County.
Grey: Vermont, New York.
Grey-Black: Vermont, New York.
Blue-Black: Pennsylvania, Northampton County.
Unfading Black: York, Pennsylvania, Maine, Maryland.
Unfading Green: Vermont, New York.
Unfading Purple: Vermont, New York.
Unfading Mottled Purple and Green: Vermont, New York.
Variegated Purple: Vermont, New York.
Unfading Red: New York, Washington County only.

There are occasional "freaks," which are opals, bronzes, buffs and browns; some of these may not be true slate, but they are interesting.

The red is particularly beautiful, but I could not get it in pieces larger than three- or four-foot squares, and consistent in quality and clarity. It polishes to a really magnificent tone. Buckingham Black has a mica-like luster; it is extremely hard, and is an especially attractive slate.

Monson Black (from Maine) is a very even and strong slate and is finished beautifully.

In ordering slate you will, of course, be working hand in hand with the architect, if it is that kind of a commission. However, should you be doing a piece of work independently, the slate suppliers are among the most helpful people you could meet. I've worked with some, and I give credit in the book to them. They can, and will, guide you through troubled waters.

Stone Magazine, a trade publication, will give you sources, information and is in general a very good font of knowledge for the sculptor working in slate. For the shipping, installing, and all those little nagging problems the sculptor has, the above sources are invaluable.

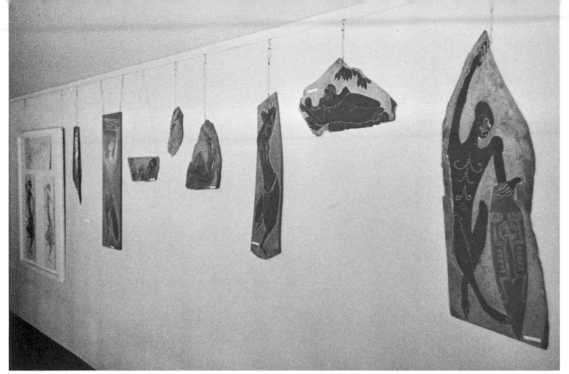

Part of the Gallery exhibiting the slates at the Fairfield University Exhibition.

African Madonna slate and the rubbing made from it. Exhibited side by side at the Fairfield University Show.

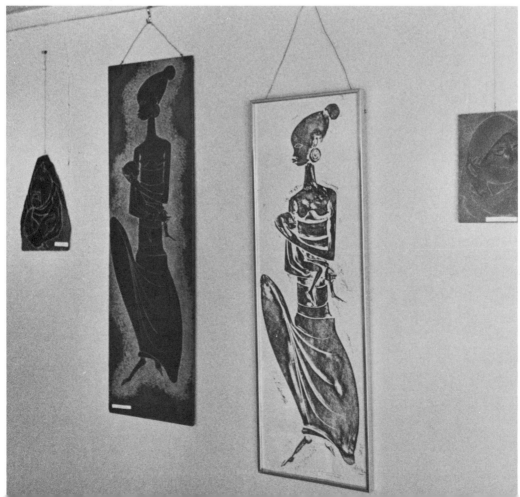

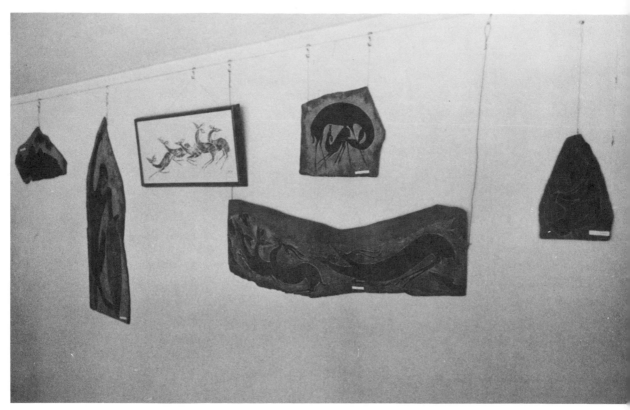

Part of the exhibition wall of the Eliscu exhibition at Fairfield University showing five slates and one rubbing.

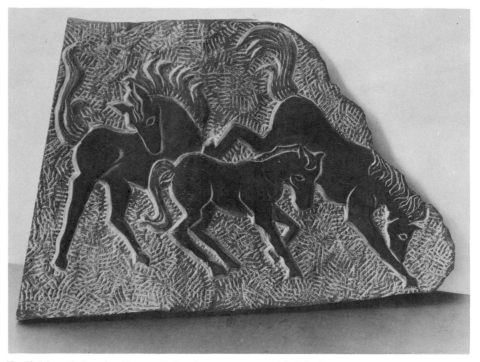

Frolicking Colts, *by Renee Erlandsen, 16 years old. Black flagstone slate.*

St. David. *Welsh green slate, 7'.*
Sculptor John Skelton,
A.R.B.S., F.R.S.A.

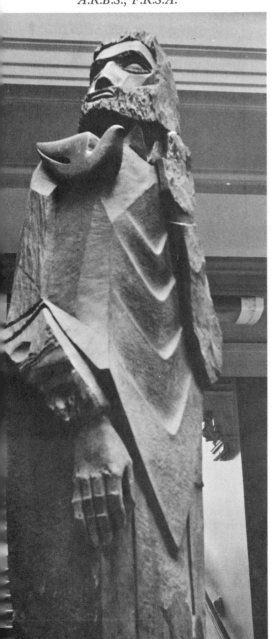

Jesus Is Stripped. Stations of the Cross. *Sculptor John Skelton,*
A.R.B.S., F.R.S.A., Ardingly College.

Jesus Is Condemned to Death. Stations of the Cross. *Sculptor*
John Skelton, A.R.B.S., F.R.S.A., Ardingly College.

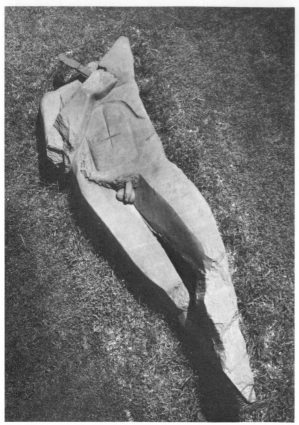

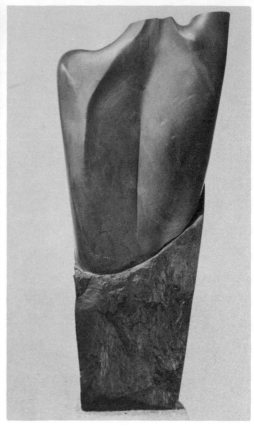

Aftermath of War. *Green slate, 8'3".*
Sculptor John Skelton, A.R.B.S., F.R.S.A.

Torso. *Green Welsh slate, 3' x 1'3". Sculptor John Skelton, A.R.B.S., F.R.S.A.*

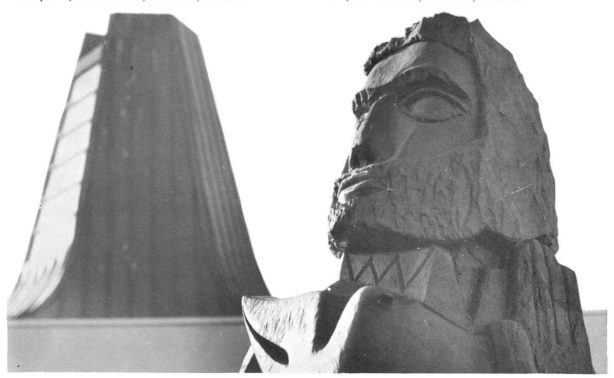

Head of St. David *for St. David's Church. Welsh green slate. Sculptor John Skelton, A.R.B.S., F.R.S.A.*

Symbol of Discovery *erected in the forecourt of the Chichester City Museum. It is carved from a rock from the Kirkstone Pass, Westmorland. Sculptor John Skelton, A.R.B.S., F.R.S.A.*

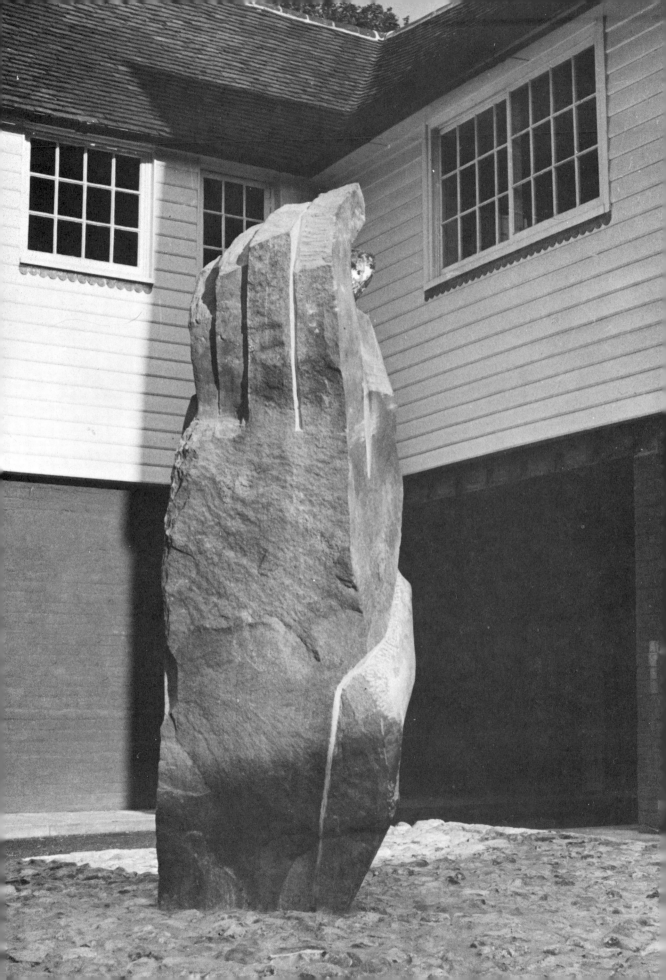

SOME TOOL
TECHNIQUES

For slate sculpture, elaborate and expensive tools are not necessary to achieve the maximum results. In fact, the simpler the tool, the better. What is important is the setup: the table to work on, at the proper height and made steady, the slate clamped firmly on the table so that it will not move while being worked on, and decent light.

Probably the most important tool is the scriber; actually, any sharp tool that will scratch into the soft surface of slate will do. I've used nails, awls, carpenters' scribers, and my personal preference is the leather working tool which is not only pointed but that also has rubber on its grip to give a better hold. What is really important in using any tool is to be comfortable with the tool itself. Working slate takes a certain amount of physical strength, and a tool with an uncomfortable handle will hurt and eventually blister your hand. I use, primarily, sharp wood-lathe chisels. These come in all sizes from $\frac{1}{8}$" wide to 1" wide, and usually have very functionally designed handles.

One tool that is extremely important is the background tool, and the tool I use most for this is called a toothed chisel. Anyone can make a background toothed chisel from a large screwdriver; just hacksaw teeth into the blade of the driver (see drawing).

The actual use of each tool is illustrated in the progression photos of the owl, but here are some hints.

After the chalk drawing on the slate is satisfactory, the first lines are scribed in with any sharp, pointed tool. This is the most important step in this whole process. Indecision will show in this line, any mistake, straying of the chalk line, etc., must be sanded out and redone. Once this outline is scratched in, by carefully going over the same line with a sharp tool, the scratch line becomes a deeper incised line, and so will guide the chisel. Going into the same line and cutting away from the form of your statue, will soon raise your design from its background.

74

One word about following a chalk line. Draw the tool toward you; it controls better. The rifflers, or rasps, as they are called, are the only tools not likely to be found in any common, ordinary hardware store. Sculpture-supply houses, art school stores, or art materials stores in your neighborhood would probably have these rasps.

If not on hand, at least they can order them for you. These fine rasps are so shaped that they can get into any form. These are very important, so take good care of them. They should last a few years, but eventually the teeth wear down.

Hacksaw blade cutting notches in large screwdriver, thus making a tool to cut background in slate.

CUTTING

Slate, in slab form (as it usually is because of its laminated nature), lends itself to being cut by a saw, and the proper saw for slate is a hacksaw, or a good hacksaw blade.

If a large, flat surface of many feet in length is to be cut, a good practice is to first scribe the line along which the cut is to be made, using a straight edge and any sharp tool. Then, by riding the blade up and down, up and down, and so on, a good deep groove will result. (Diagram *A*.)

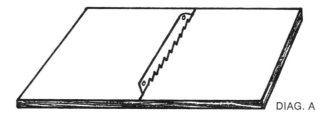

DIAG. A

The next step is to turn the slate over onto its other side, after having made two hacksaw cuts through the edges of the cut line. (Diagram *B*.)

DIAG. B

After the slate is turned over, it looks like this. (Diagram C.)

DIAG. C

Then, with your straight edge, draw the line between the two cuts and repeat the cutting on the new side. You can now easily break the slate along the prescribed line or cut right through, if you have the patience.

DRILLING

Slate can be drilled either by hand or with an electric drill. While it is soft enough not to require a carborundum or any special drill, care must still be exercised and, for the best and surest results, one should drill slowly.

If drilling by hand with a brace and bit, just the slow rotation of any drill—one even with a sharpened nail in the bit—will go through slate. A fast electric drill will cut through, but it will also dull your bit.

A good practice is to put a piece of Scotch tape, or masking tape on the surface on which the drill will emerge (usually the back). This will prevent chipping around the edges of the slate as the bit breaks through.

TEXTURES IN SLATE

Tone and texture are as important in sculpture as in other art forms. In fact more so, because the sculptor is limited to the color of his medium, be it clay, stone, wood or bronze, and within the boundaries of that one color. The sculptor must use textures for tonal qualities of his medium to highlight or accent the forms. The painter can use darker colors to shadow forms, or highlights of color to call attention to pertinent parts of his work. The sculptor must, by his skill in the disciplined use of textures, create areas of interest within the confines of the color set by his medium.

In this slate, *The Odalisque*, we are working with a solid red color and, while red slate is rich and beautiful to start with, it loses its impact unless the polishing is judicially controlled. Were the entire modeled surface polished, the texture of the background would lose its impact and its sense of dramatic contrast.

There are many textures possible in sculpture for, as the surface of the stone is broken so is a texture created, and the different ways of changing the surface are by use of a pointed tool or a toothed tool or even by sandblasting. All these create different, textured surfaces.

In *Odalisque* we have used a toothed chisel for the background, and a pointed tool for the drape. But there are many other types of tools that sculptors use; one is a bushing hammer or a bushing tool, which is more or less a cluster of points. But this we will discuss later and in more depth when we get into soft stone sculpture, as the bushing tool is very important in surfacing stone sculpture in the round and is not really feasible on slate. Actually, an ordinary screwdriver used in a "running" technique is as good as any other tool for a slate background. But it is my feeling that each person working with slate will find the most advantageous tool to make the texture that is best suited to the particular work.

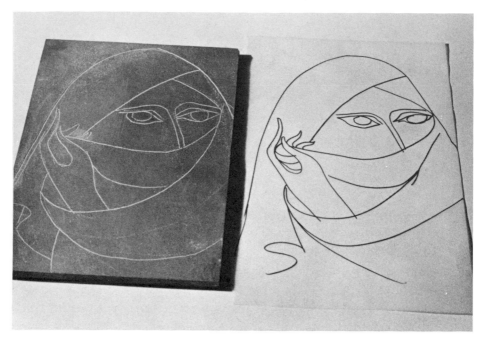

Red slate, with drawing chalked on slate, and the original drawing.

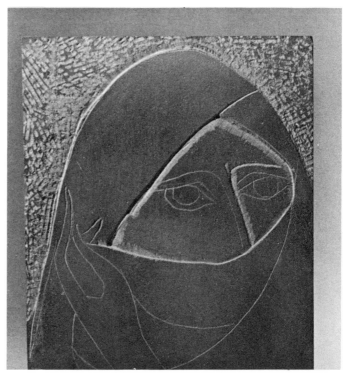

The background is cut with toothed chisel for texture. We now start to model the face. The lighter areas are chisel cuts.

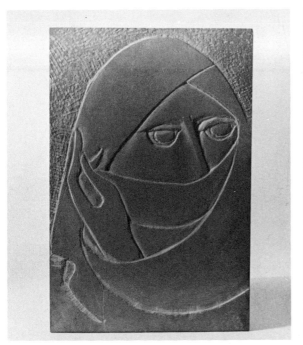

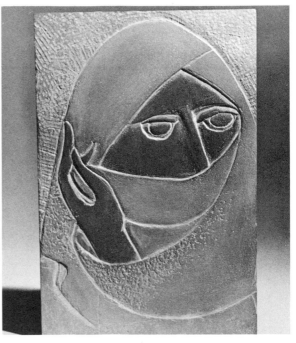

The slate is now textured and modeled, but needs polishing for tone and contrast.

The flesh areas only are polished, and a new texture, a stipple, is added to break up the large expanse of drape.

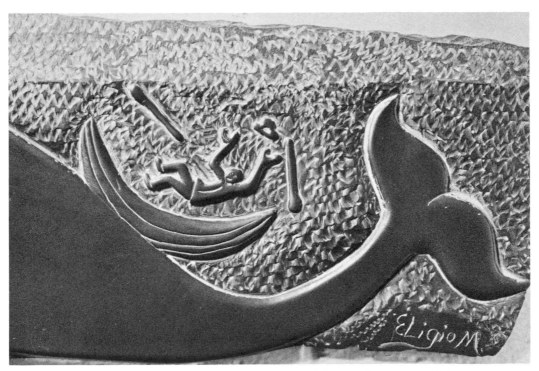

Detail of slate Moby Dick. The background is made with an ordinary screwdriver, using a rotating motion of the wrist. The screwdriver "runs" and textures the slate.

81

SLATE SLIVERS

Fragments are usually made from broken pieces of slate; some of these broken fragments are large pieces with clean breaks, and others are small, paper-thin slivers. By the very nature of its structure, slate, when broken, is apt to fragment in small, thin sheets. The fragility of these pieces may present a challenge to the average worker in stone, but with care and a delicacy of touch the result can be most interesting.

One of the joys of working slivers is the opportunity to silhouette a form rather than to rely on a textured background. Very often the background is too thin for texture, so, with a rasp or hacksaw blade, the background is cut away and the resulting form, freed of any background, can be most attractive. A combination of some background and parts of the sculptured form free of background make a most interesting piece of work.

One of the hazards of working with slivers is the ever-present danger of the sliver breaking, as rarely will the back of the slate be perfectly even, and so the pressure exerted in working the surface, especially the background, will often break the thin slate. There is only one thing I can suggest, and that is to work with care, extreme care, and it usually works out. If, however, a piece breaks off, all may not be lost. In fact, I think that of the slivers I have broken, I have "saved" 75 percent by redesign. The slate in this photographic series gives a good example.

Slivers, because of their thinness, weigh almost nothing and are easy to mount and frame, so they have the added advantage of being exhibited more easily than the average piece of sculpture.

I have used colored felt (usually red) and mounted my slate slivers on the felt (using epoxy). The use of color with the slate is very gratifying.

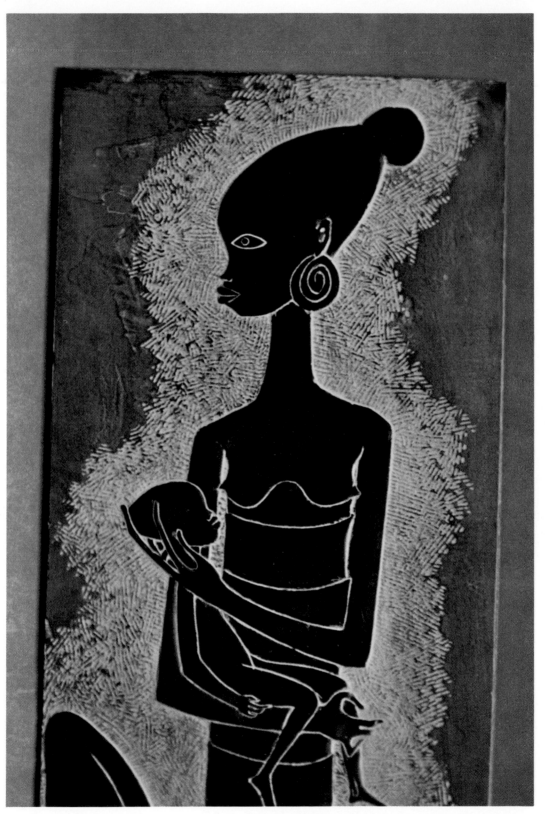

African Mother and Child. *Black slate. Frank Eliscu.*

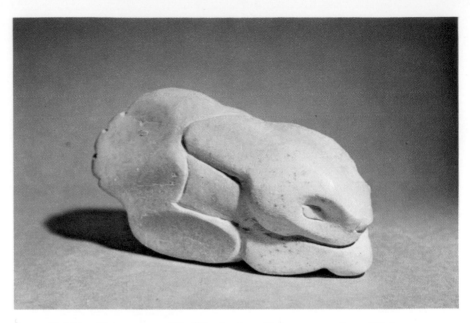

Rabbit. *Greenstone, 12". Work of a 10th year student. High School of Art & Design, New York.*

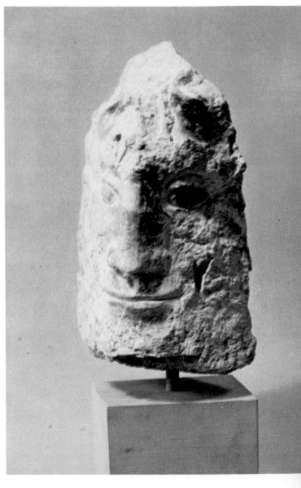

Falcon. *Greenstone, 9". Frank Eliscu.* Pan. *Greenstone, 10". Frank Eliscu.*

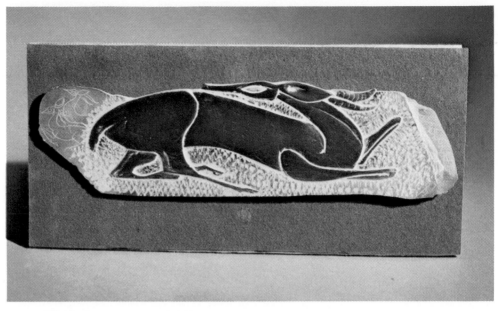

Fawn. *Black slate, 12". Frank Eliscu.*

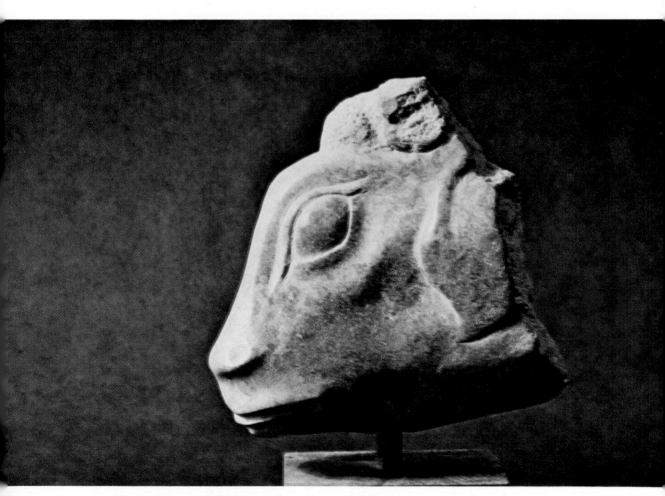

Head of Young Bull. *Greenstone, 6". Frank Eliscu.*

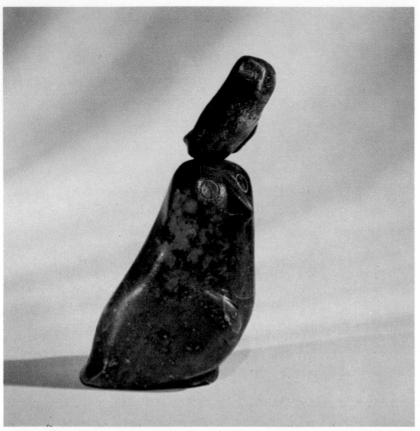

Eskimo Sculpture. *Soapstone. NFB —1962. A carving showing an owl with its young perched upon its head. The carving was done by Tudlik, Cape Dorset, N.W.T.*

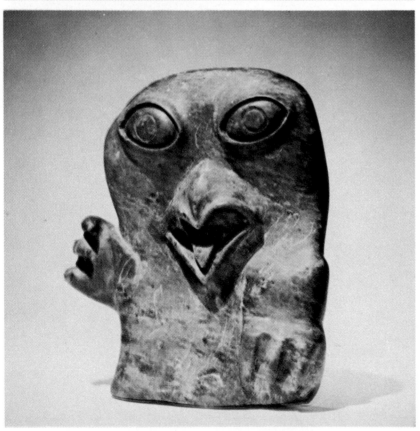

The Spirit. *Eskimo carving. Soapstone.*

Fighting Stallions. *Black slate, 12". Frank Eliscu.*

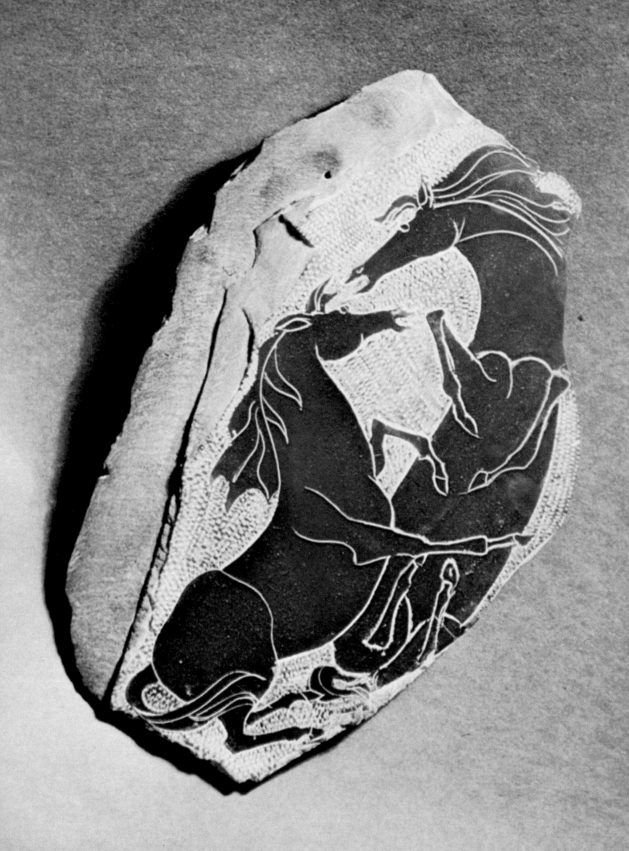

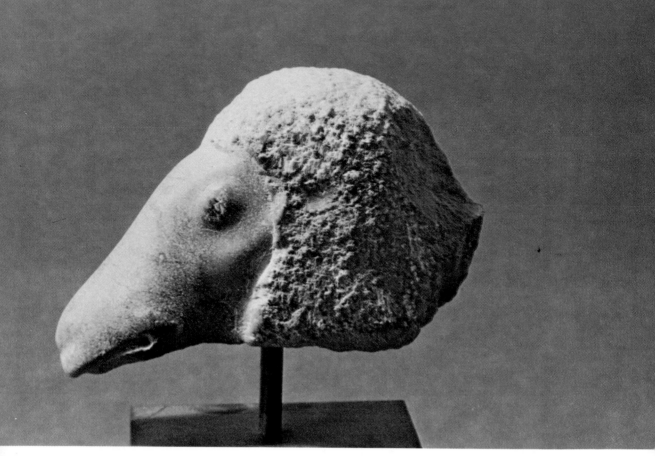

Sheep's Head. *Greenstone, 8". Frank Eliscu.*

Ram's Head. *Greenstone. Frank Eliscu.*

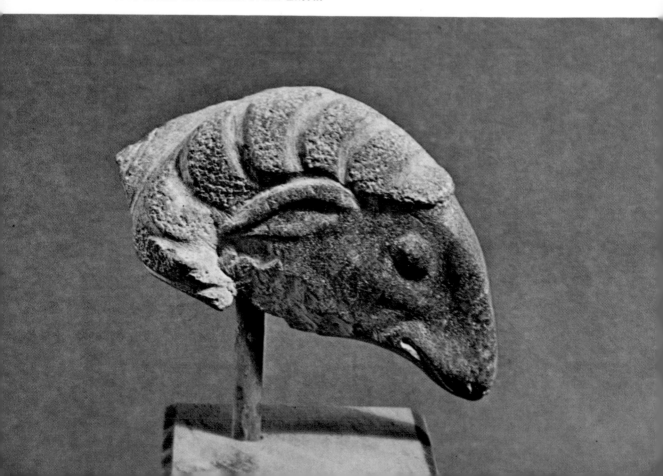

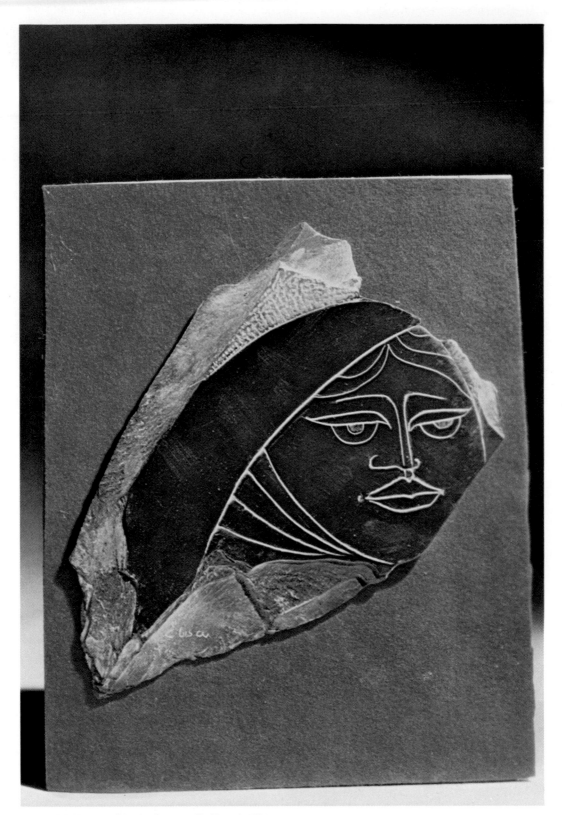

Odalisque. *Black slate, 10". Frank Eliscu.*

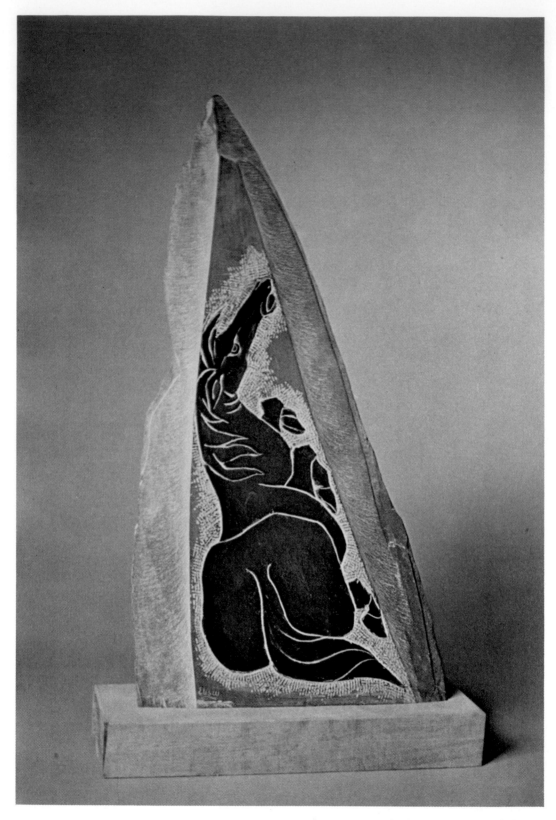

Seated Horse. *Black slate, 22". Frank Eliscu.*

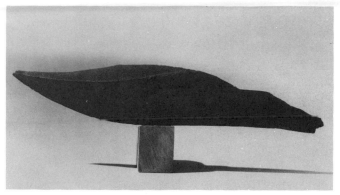

Slate sliver.

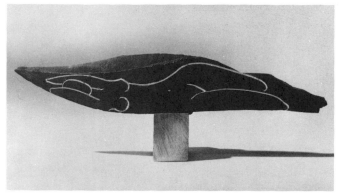

The flowing lines of this nude would work very well with this sliver.

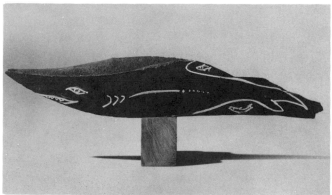

This Shark seems to have the best possibilities, especially the way the fin works into the shape of the sliver.

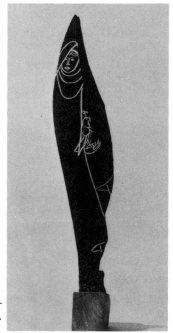

The sliver, held vertically, suggests the possibility of Woman with a Falcon.

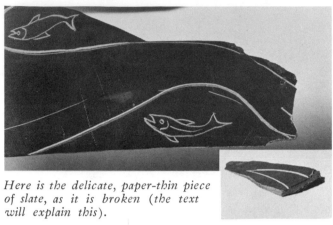

Here is the delicate, paper-thin piece of slate, as it is broken (the text will explain this).

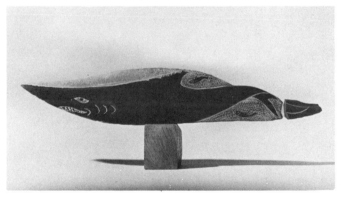

This photo will explain the "salvage" job on this slate far better than a thousand words.

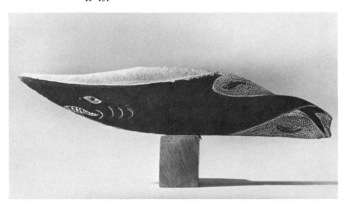

The Shark. *As it was to have been—and how it is.*

The Shark. *Finished, and who would know it had been broken?*

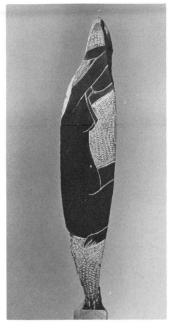

This nude shows just enough to suggest the rest of the figure.

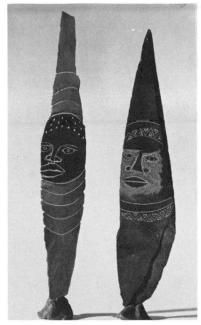

African Shields, *made from slivers of slate, 4" high each.*

Jungle Mother. *Black slate sliver. The hand holding the group indicates the size of this sliver of slate.*

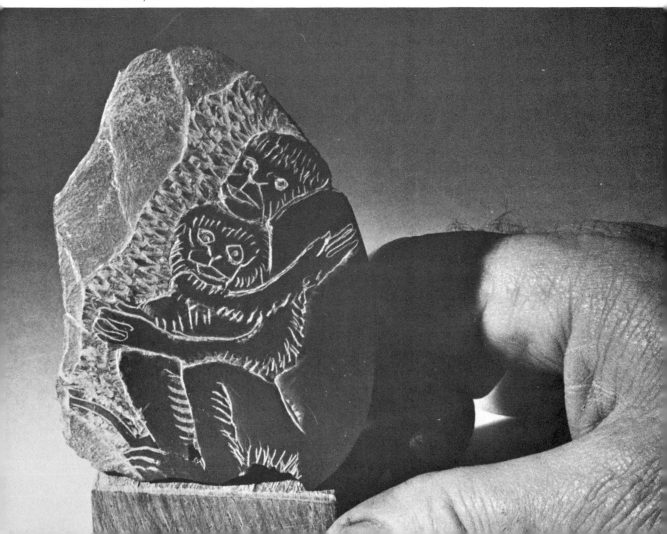

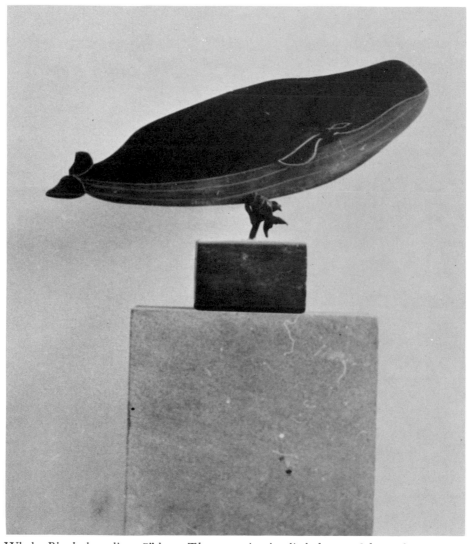

Whale. *Black slate sliver, 7″ long. The mounting is a little bronze fish cast from a wax.*

SLATE FRAGMENTS

Slate, when broken into fragmented shapes, presents a real opportunity for an exciting design, for odd shapes not only challenge the imagination but also force you to design in a more unusual fashion than you would ordinarily. First, you are presented with a new shape—say a triangle—and if you are planning to do something specific, such as an animal or figure, or a group of children within this shape, you can easily come up with something far more interesting than if you worked with no shape designated. When one looks up at the clouds, think how those nebulous shapes in the sky become definite, and in imagination one can see any fantasy the outline of the cloud suggests. The fragment offers very much the same feeling. You must concentrate to see what form is trapped in that odd shape before you, and it is surprising what will emerge.

Elsewhere, in discussing slate I talk of slivers. These are also a type of fragment, but so small and often so fragile as to limit sculptural possibilities.

A fragment of slate in its raw, uncarved form will give an added quality to the design—that of the sense of immediacy—or will make a work of art out of what happens, as well as what the artist does. By adding very little to fragmented pieces, the mind of the viewer fills in the unsaid parts of the work. And, as we are dealing in an art that is its own form of communication, the same rules that apply to all arts apply here. What is not shown, but implied, can be every bit as important as spelling out every detail.

In *Torso* it's the strange shape predescribed by the fragment that gives the torso its sense of freshness.

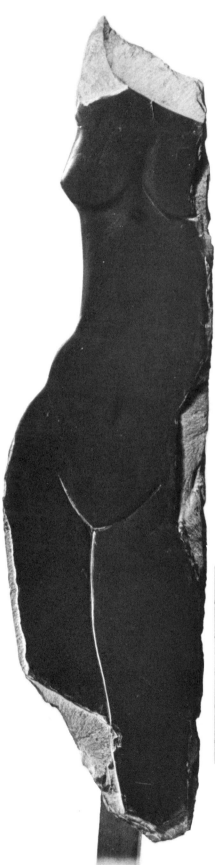

Torso, *from a fragment. This piece of slate is 21" high x 6" wide, and very little was cut away. Incidentally, this is mounted on a base, making it a free-standing piece of sculpture.*

Jonah, *in a fragment. A slight change in the outline makes the fragmented slate a fishlike shape. This slate is 25" x 10".*

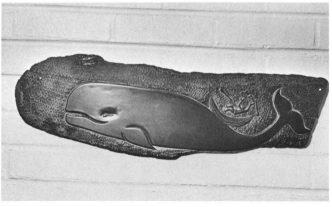

Moby Dick, *a slate fragment by a young student. The primary tool was a screwdriver.*

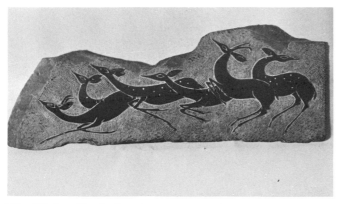

The Flight. *Black slate fragment of deer.*

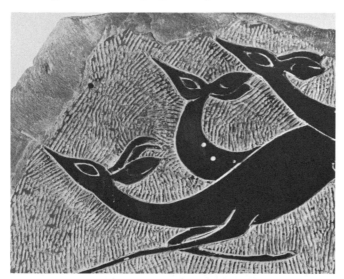

Detail of The Flight.

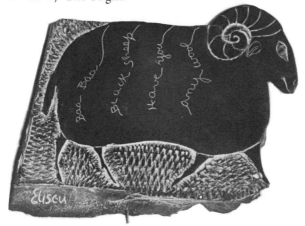

Black Sheep. *Uses the words of the nursery rhyme for its design.*

SANDBLASTED SLATE

In discussing the cutting of slate by use of sandblast we come into an almost purely commercial, or rather industrial, approach to slate work.

Sandblasting is used extensively by monument workers for cutting into granite, marble or any other hard stone.

In actual practice any design desired is copied onto a specially prepared frisket or mask made of thin rubber already treated with an adhesive on one side so that it will adhere to the smooth stone. The areas to be blasted are cut away and the rubber then becomes a protective mask which will resist the sandblast. This method is most practical for cutting letters into stone, and it also works very well with slate.

Any generalization, such as I have made about sandblasted slate being a purely industrial or commercial approach, is subject to exception, and one such example comes to mind. A group of artists who are working in slate, travertine and glass are doing some excellent and highly original relief sculpture, using a basically sandblast technique, plus a new means of masking the slate. I do not believe they use rubber as the medium to repel the sandblast. They have developed a new method that is completely their own, and which allows for greater detail and delicacy of delineation. This group, called ILLI, in St. Louis, sells its works to the better decorators, or works on commission.

Illustrated here is one of their works. I think it shows that artists can take the most commercial techniques and, using good design combined with taste, produce works of art.

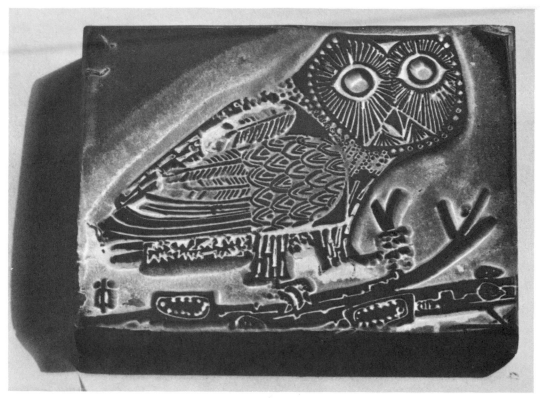

Owl, *only 3″ x 4″ by Illi, Inc., shows the possibilities inherent in sandblast technique.*

Knockout! *Detail from the large slate—in which the background was sandblasted.*

RUBBINGS
FROM SLATE

One of the fortuitous dividends of working in slate is the opportunity to do rubbings from some of your favorite slates. Rubbings, as a form of art, became quite popular a few years ago, and not only were people doing rubbings from old tombstones (some of these slate), but a fad developed of also doing rubbings from old English brass engravings used on tombs.

The most common rubbings were those done from Indian and Siamese stone reliefs, and the artists of Bangkok do a thriving business today selling rubbings of some of the temple stone reliefs. The actual technique is about the simplest of all reproduction methods. If you are of the age to remember, recall when you were young and someone showed you how to make a copy of a penny, or any coin, by putting a piece of paper on top of the coin and then just filling in the entire area with pencil, or even rubbing the surface with a smudgy finger. The results seemed almost magical in those days, for the picture on the coin surface would emerge as you penciled or rubbed. To be very honest the results seem just as amazing to me today, for I must admit to being thrilled when, with a simple stroke of the crayon, I see the forms take shape.

Today I use grease crayons, and the reason for this is that a good lithograph crayon takes the surface of the paper extremely well and will not powder off as does Conté crayon or pastel. However, any grease crayon, the type used in children's coloring sets, is excellent.

The process is so simple that the materials become the important part of the technique. By this I mean that, if one uses a paper compatible to the process and the correct type of crayon, the result is a most professional looking piece of art.

I have only touched on this one method of rubbing, but there are many people who pursue this technique, and who achieve some really fine results using inks and rice papers and all sorts of variations of the basic approach I have described.

However, the art of rubbings, fascinating as it is, is only touched upon tangentially here. It is for you, the reader, to go on with this art form if you enjoy it. Here is, incidentally, a simple explanation of how the Chinese do rubbings. A piece of dampened paper is placed over the carved stone and pressed into the engraved lines. Then you brush over the paper with ink, leaving the depressed areas white. Rice paper is very suitable and most interesting, as the paper itself has a beautiful texture.

The paper to be rubbed is placed on the slate and taped down so that it cannot move or shift its position during the rubbing.

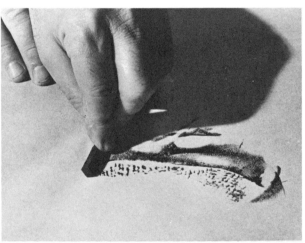

The crayon is drawn across the surface with a firm stroke, and the drawing emerges almost magically.

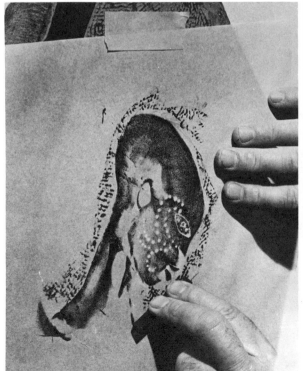

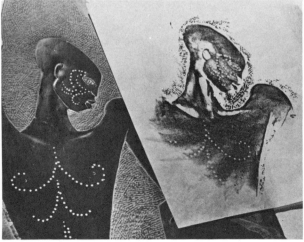

This photo, more than words, tells of the honesty of the rubbing as a process of reproducing a piece of art.

Even the background can show an interesting touch, for the beauty of the rubbing is its quality of purity of line and its simplicity of drawing.

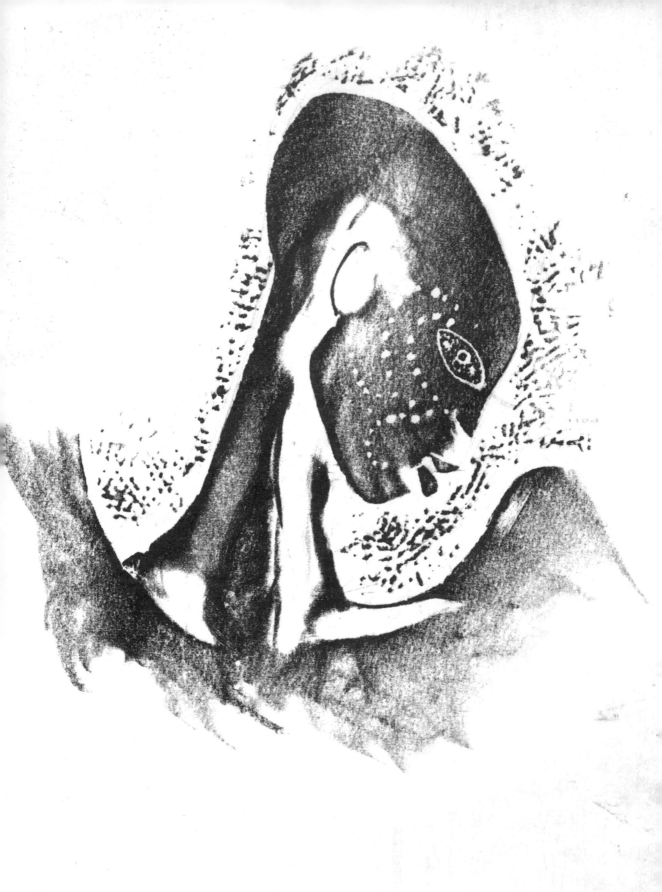

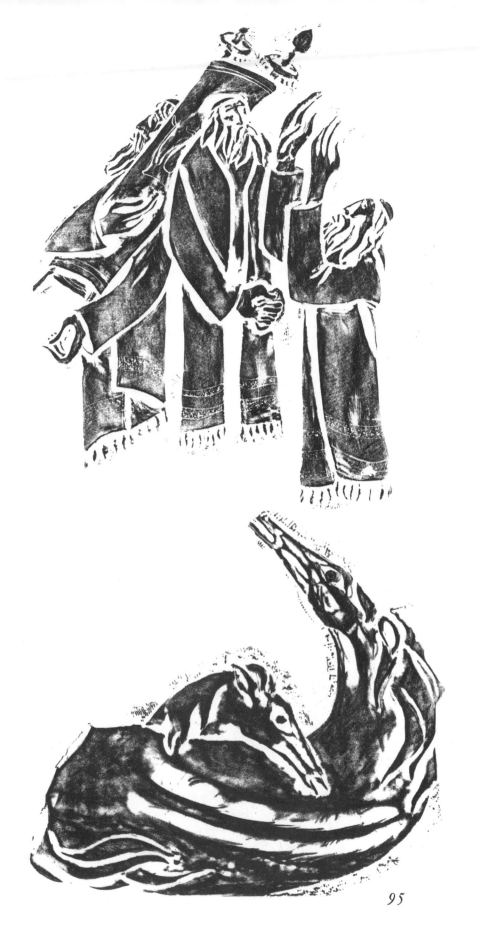

95

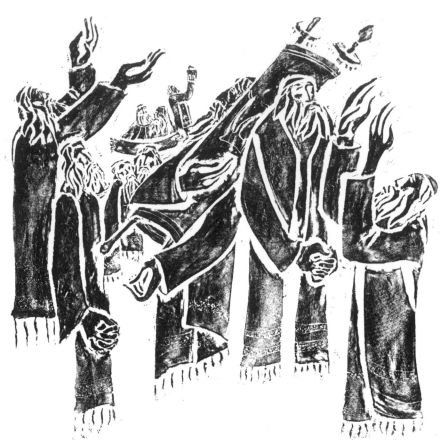

96

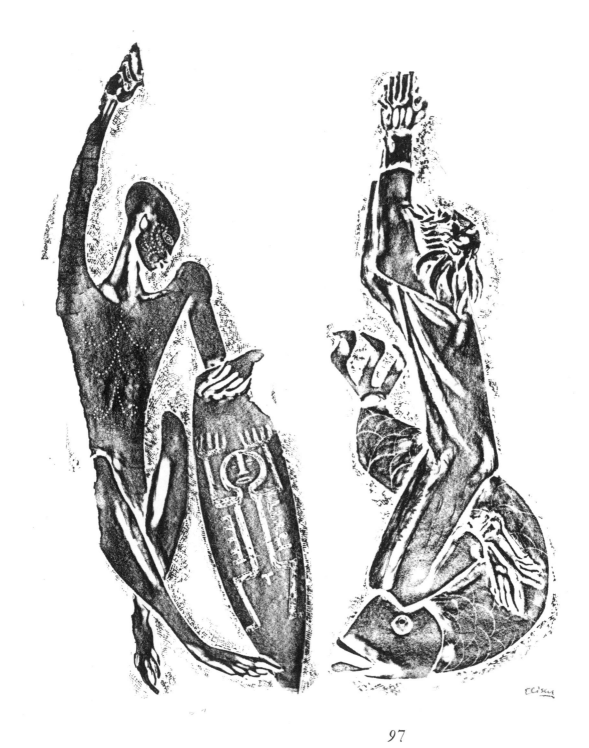

97

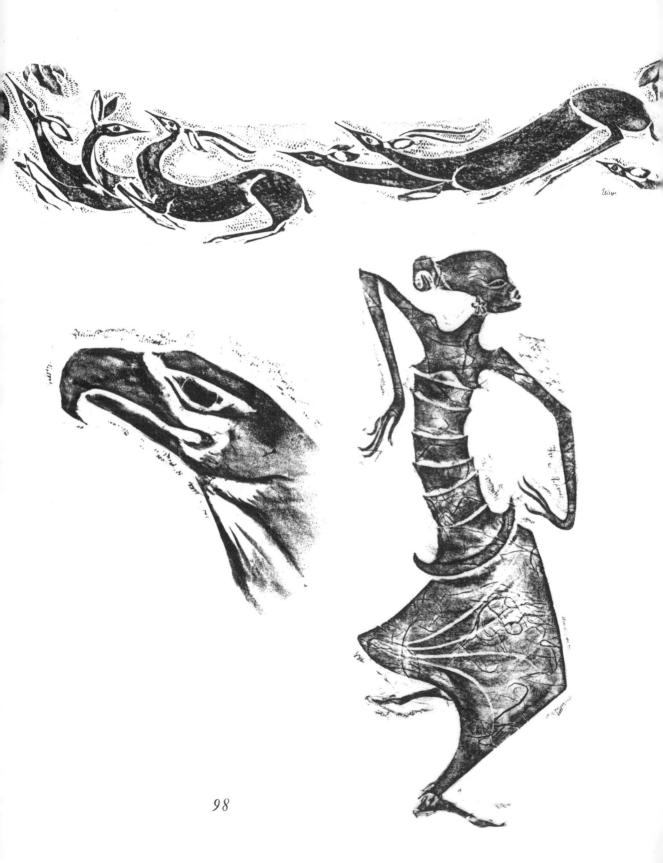

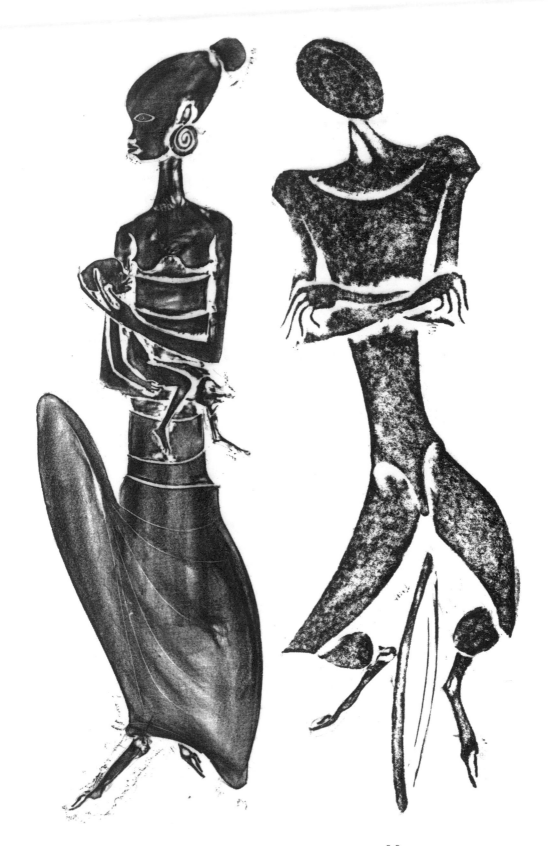

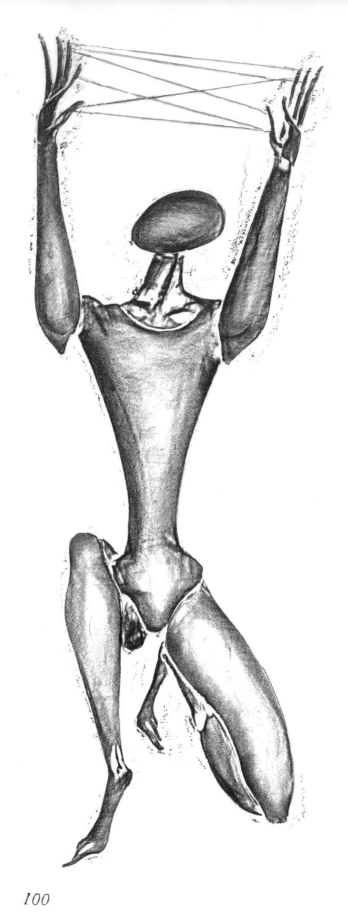

100

SLATE IN BAS-RELIEF PORTRAITURE

Working on a slate relief calls for a real sense of drawing combined with an understanding of how to handle low relief.

One of the more esoteric forms of sculpture is the coin medal, one of the lowest reliefs that sculptors usually work. The relief on a medallion approximately 12 inches in diameter would be raised no more than $3/32$ of an inch and the edges coming down to $1/32$, and so the average amount of relief is about $1/32$ or $2/32$nds of an inch.

Working in slate, a carving, rather than modeling process, tests the skill of the artist in his quest to give a completely three-dimensional feeling on the flat slate. For the slate relief is just as low or even lower than the coin medal relief. To work a real low relief calls for much more skill and sculptural understanding than high relief.

Slate has many virtues to recommend it as a vehicle for a bas-relief portrait. Primarily, it is an even matte color without any veining or distracting spots of color that can so easily destroy a portrait.

I have used both the red—a lovely, warm raspberry-toned slate—and the black; with each I found I was able to faithfully follow my drawing and arrive at the desired result.

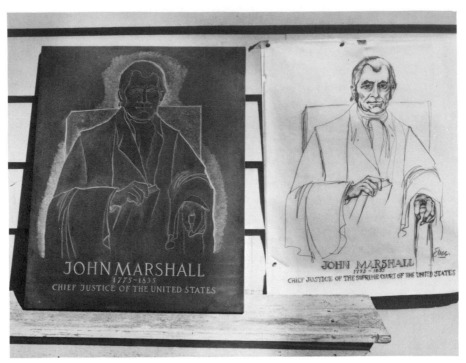

John Marshall, *slate relief portrait, with the sculptor's drawing that preceded the slate.*

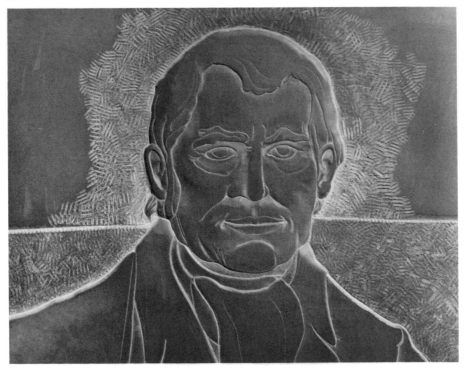

John Marshall, *slate relief. This close-up shows the very low, or "Coin Medal" relief-modeling.*

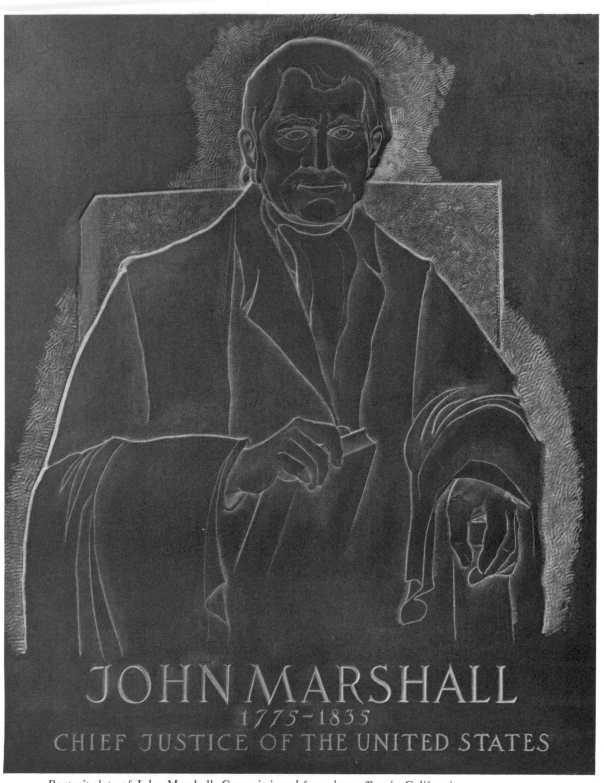

JOHN MARSHALL
1775~1835
CHIEF JUSTICE OF THE UNITED STATES

Portrait slate of John Marshall. *Commissioned for a law office in California.*

ADDED USE OF COLOR IN SLATE SCULPTURE

Adding color or any embellishment to a piece of sculpture is rarely satisfactory. A good piece of sculpture should stand or fall upon its merits as a studied form or series of forms. There have been, however, certain isolated instances where color has been used, and very sucessfully.

The Greeks, of course, polychromed many of their stone pieces, and the famous *Charioteer at Delphi* is a beautiful bronze that loses nothing by having eyes of white agate.

The Chinese used color in the addition of lacquer to wood sculpture.

The various interpretations of the Virgin and Child, in fact, almost all ecclesiastical wood sculpture, was polychromed. The Egyptians not only used color, but gold and precious stones as embellishments were also common practice.

The one fact to be kept in mind is that, in sculpture, the use of any embellishment, color or mixed media almost always will produce something in poor taste.

If a particular piece of sculpture calls for the use of color, gold leaf or what you will, it must be handled with the utmost restraint. It should be so much a part of the overall design that it never is noticeable as an addition, but is seen as an accepted and integral part of an overall scheme. The African studies are an example of a bold addition of white tattoos to an already existing piece of sculpture. Without the white tattoo design, the sculpture would hold together just as well, but the tattoo adds interest without detracting from the piece itself. The same can be said of the gold leaf in the eyes of the lions of Daniel. In fact, the gold leaf neither adds nor detracts, but gives, I think, a stronger focus on the lions' heads, an important part of this design.

Here is a resting fawn. With a piece of chalk we will add the white markings so definite on a fawn.

Unless these markings can improve the design quality of the slate, they are superfluous. So we work until the actual design of circles are pleasing rather than realistic.

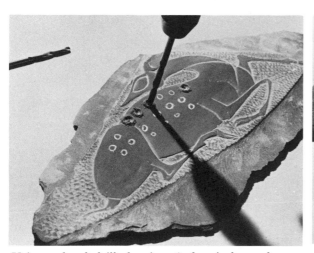

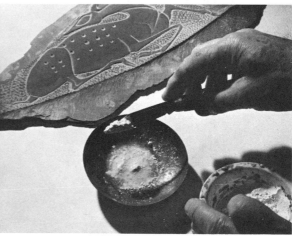

Using a hand drill the size of the circles and a brace, we drill very slightly into the slate and recess the circles.

We now mix a small amount of plaster (or gesso, or whatever you wish, for the circles).

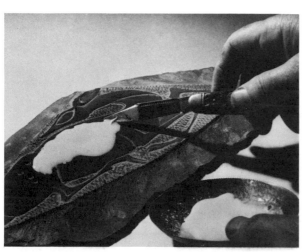

The mixture, of a cream-like consistency, is laid over the circles, and then allowed to set.

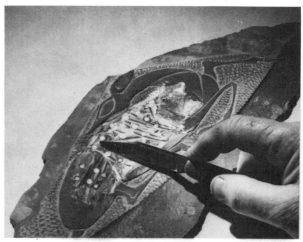

When the mixture has set, or practically set, it is scraped off the surface of the fawn.

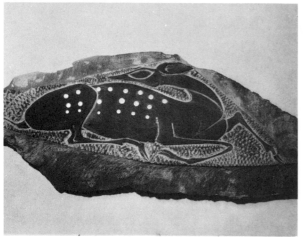

Using steel wool, fine sandpaper, all the superfluous white is taken off the fawn.

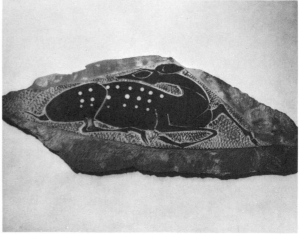

Finally—now we polish! Wax over the entire fawn—white circles and all—and we do have something interesting.

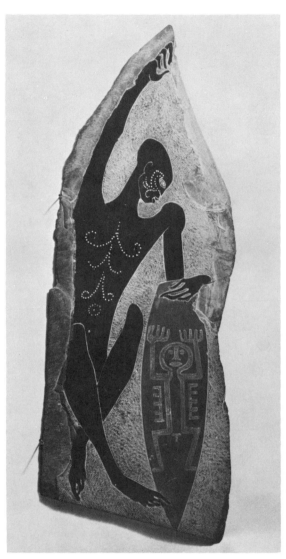

Here we use the white markings to show tribal decoratings in an African theme.

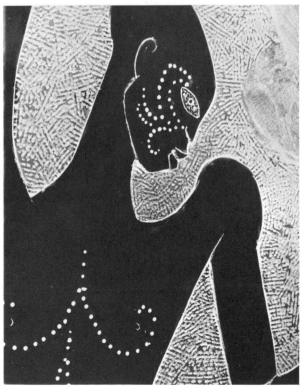

Detail of African Drum.

107

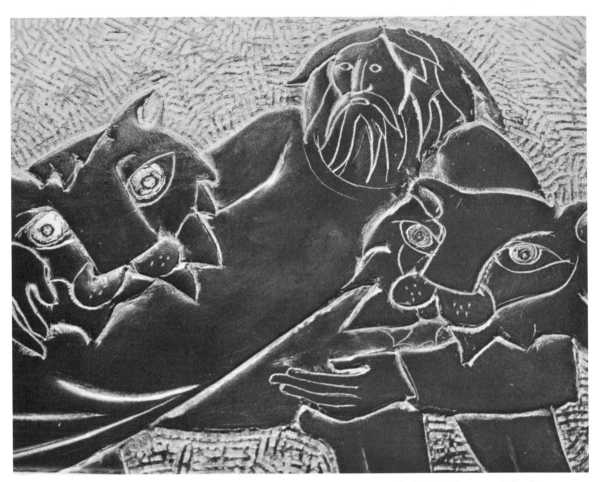

Gold-leafed eyes of the lions.

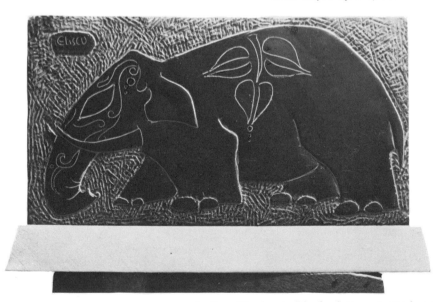

Indian Elephant. *Black slate, mounted on teak. 10" x 6".*

SLATE RELIEF
IN ARCHITECTURE

Slate, in itself, is a most handsome medium, and its decorative possibilities are endless.

However, for a full appreciation of its character, slate must be seen as an integral part of an architectural design in which the slate becomes not only a decorative note, but also serves as a functional part of an allover scheme.

There are many new materials used in architecture and some of them are quite beautiful, rich in both texture and color, but the elemental and earthy quality of slate gives a feeling of integrity and agelessness that many of the newer media lack.

Speaking from a purely personal viewpoint, I have always felt that "ersatz" media, such as polyacrylics, have a tendency to look dated in a very short time, and any piece of sculpture or ornament used in conjunction with architecture must have more of a life span than a few years.

In some of the buildings that have used slate sculpture as a part of its design, the functional quality was of prime importance.

For example, in the Diamond Exchange Building, on Sixth Avenue, New York City, the decorative slate door is in fact a fire door and this precluded the use of wood or any other material that was not fireproof. On the other hand, the "horses" in the Bankers Trust Building, 529 Fifth Avenue, New York City, is purely decorative, and is a complete wall between two banks of elevators, used to give life to an otherwise dead space.

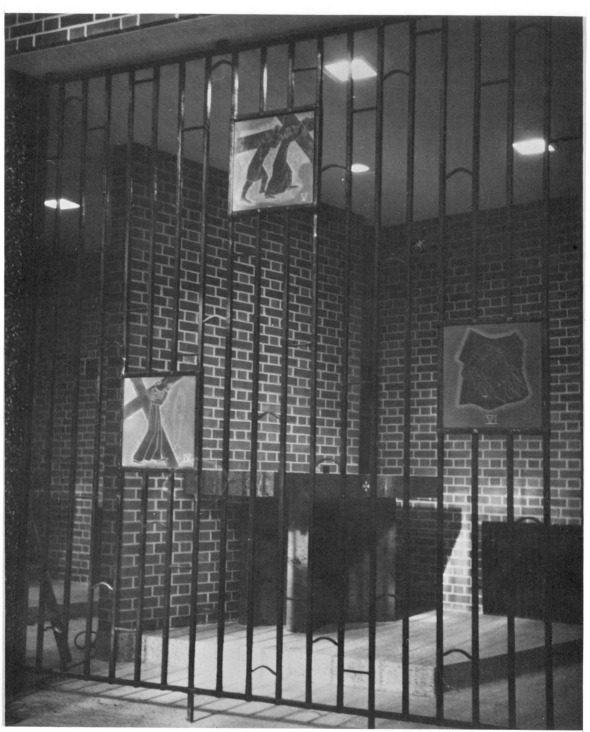

Slate Stations of the Cross, *set in a wrought
iron grille. For the Father Judge Seminary,
Lynchburg, Va. James Cannizaro, Architect.*

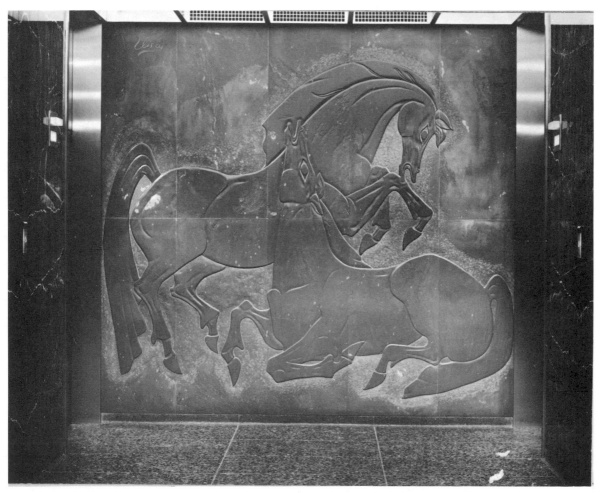

Horses. *Purple slate, 10' x 12'. Bankers Trust Building, 529 Fifth Avenue, New York City. This slate is the entire wall between the banks of elevators. Emory Roth & Sons, Architect.*

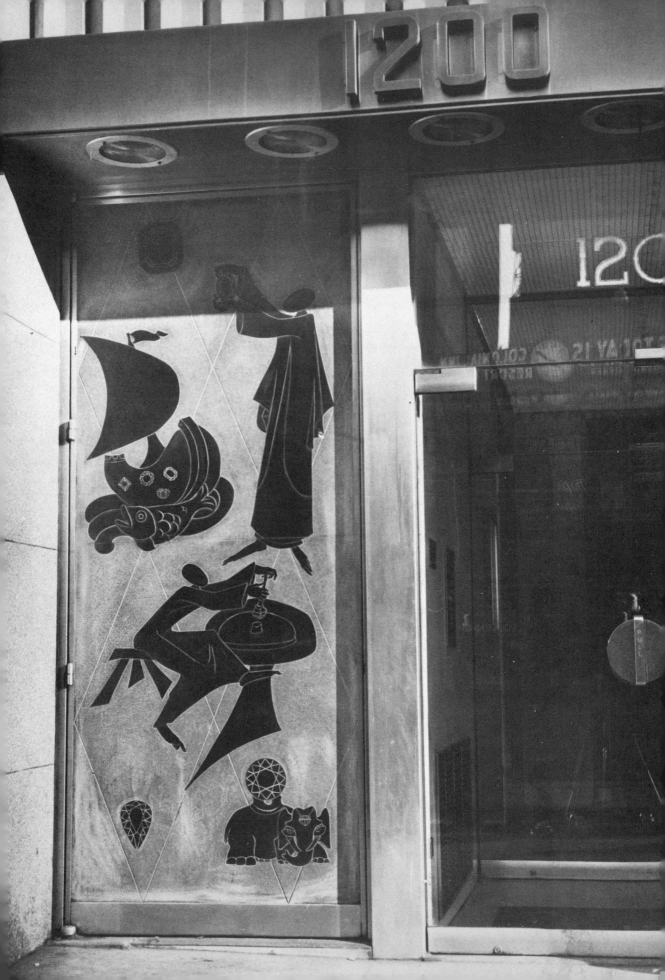

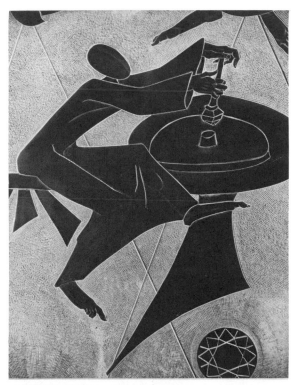

Detail—Diamond Center, slate door.

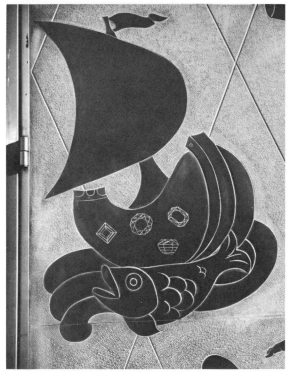

Detail—Diamond Center, slate door.

SLATE IN
HOME DECORATION

The obvious and natural place for slate as a piece of decorative art is as a wall decoration, competing with paintings and drawings to capture the eye of the beholder.

There are, however, other and, I believe, equally as interesting, uses for slate. The fireplace is one, and I show its use in the chapter, "*Architecture and Slate.*"

The enterprising artist with a sense of ingenuity will come up with other and even more interesting solutions. One that I particularly like is the slate coffee table; nothing new there until you carve it, and then it becomes both unique and decorative.

In my mind I've toyed with the idea of using the thin blackboard-type slate and doing a weather vane, but, intriguing as the idea is, I've never gotten down to it. I throw it out to anyone who likes it. Only the decorative part of the vane would be in slate. Here is a suggested drawing.

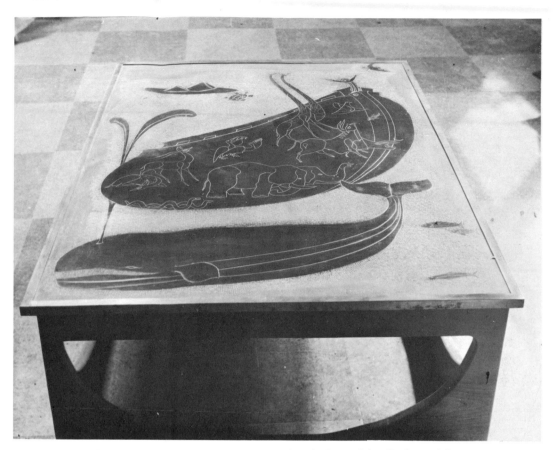

Noah's Ark, *slate coffee table, 3′ x 5′. This black slate is framed in 1″ channel brass, and is set onto a teak, specially designed, coffee table.*

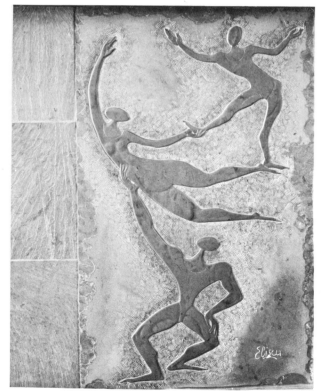

Acrobats, *9′ x 5′. Green slate used on a fireplace wall in a country residence. Architect: Fred M. Liebmann.*

115

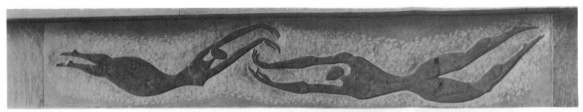

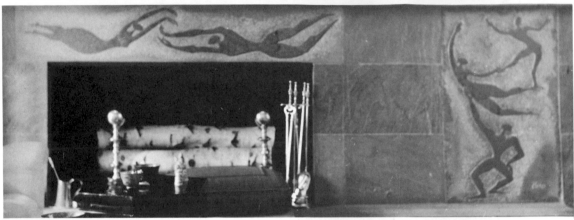

Acrobats, *the green slate fireplace decoration over the hearth opening and alongside the main wall decoration.*

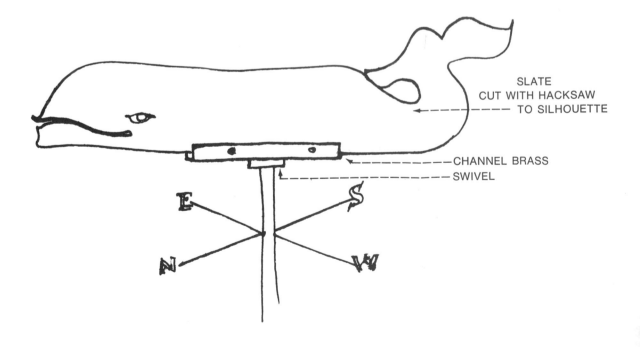

SLATE
CUT WITH HACKSAW
TO SILHOUETTE

CHANNEL BRASS

SWIVEL

E

S

N

W

ESKIMO STONE SCULPTURE

The American Indian, primarily a huntsman, and living a nomadic life, never really developed an art heritage, as did some of the other tribal cultures. There are, of course, the totem poles of the Northwest Indians, and the pottery of the Indians of the Southwest, but by and large, the American Indian, in his nomadic state, never achieved, for instance, the artistic stature of the Pre-Columbian Indians. It is therefore surprising that the Eskimo, basically a nomad, and a hunter living in the Arctic, a harsh and bitter land, created such a highly sophisticated and personal form of sculpture.

These are not colossal statues like the Easter Island heads, nor tree-sized monuments like the totem poles of the Northwest, but rather small (by sculptural standards) stone carvings. When the brutal Arctic winter curtails any hunting or outdoor activity the restriction of working in an igloo, or perhaps a small hut, naturally demands working in small scale. As the available medium often determines the particular art form any tribal culture pursues, it also seems to sharpen the skills of its practitioners, and to lead him into the techniques necessary, so that with the most primitive tools the tribal artist emerges with the most beautifully finished piece of art. The stones indigenous to Alaska and Canada that the Eskimo usually works with are steatite, serpentine and ampholite.

It is true that the Eskimo carves in bone and walrus tusk ivory, as these are the other two media available to him. But stone, with its diversity of size and shape, allows for greater creative options. Incidentally, I do not recall seeing any Eskimo sculpture in wood, and I would venture that it would be rarely, if ever, used.

The stone carvings are masterful in their sculptural quality. They are simplified, almost to the point of abstraction in some cases, and they almost always tell a story, whether it be a legend of "The Spirit," or of a statue of a hunter and a seal.

The tools used by the Eskimo for his stone carving are primitive by our standards, but not in the results. Not by any means. Basically, the Eskimo uses only his knife, a bow drill and a rough stone. He uses no rasps, chisels, bushing hammers or sandpapers. The rough stone is used to smooth after the knife rough cuts the stone. When the completion of the statue is near, it is then immersed in seal oil. After a few days it is taken out, then hand rubbed with fine stone dust, and finally just with the hands. This final caressing with the hands is as old as the art of sculpture, and I know of many workers in stone who do this today. I think that the special relationship between man and a beautiful piece of stone, especially when the beauty of the stone has been used to enhance the creative idea of the artist, is as old as time and as thrilling as tomorrow.

A final word: the work of the Eskimo is a natural growth. Because of climate, the available material and the enforced periods of confinement Eskimo sculpture has not as yet been bastardized by the "more advanced" cultures.

I personally find Eskimo sculpture especially beautiful because it is their own art and is an honest and expressive form of communication. The most elaborate technique, or dazzling piece of monumental carving cannot compete with the sincerity of the Eskimo in his igloo telling his story.

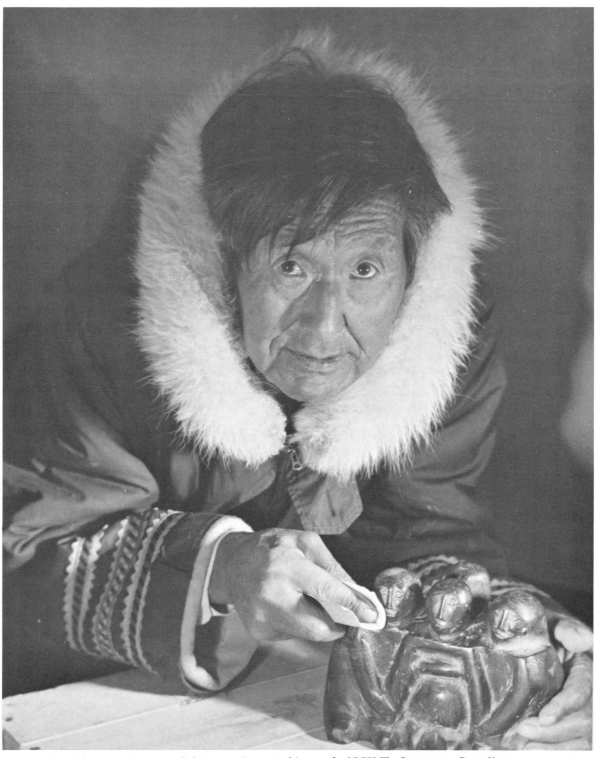

An Eskimo sculptor polishing a piece of his work—N.W.T. Courtesy, Canadian Government. Photograph NFB, 1963.

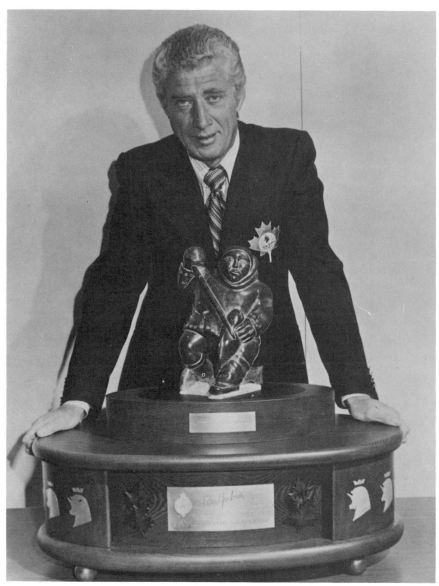

One of the most unusual Canadian sports awards ever designed—the Peter Jackson Trophy—was to be presented to the winner of the 1971 Canadian Open Golf Championship. Conducted by the Royal Canadian Golf Association, the Canadian Open was played at Montreal's Richelieu Valley Golf and Country Club, July 1–4. Displayed here by Peter Jackson Golf consultant, Al Balding, the trophy is constructed entirely of native Canadian materials. The tournament winner will retain the Eskimo carving on its base, which will then be replaced by a new carving to form the 1972 trophy. Courtesy, Canadian Government.

120

Eskimo sculpture. Courtesy, The Rock Shop, Bar Harbor, Me.

Eskimo sculpture. Courtesy, The Rock Shop, Bar Harbor, Me.

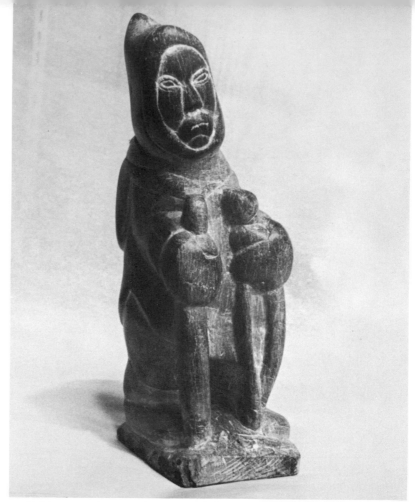

Eskimo sculpture. Courtesy, The Rock Shop, Bar Harbor, Me.

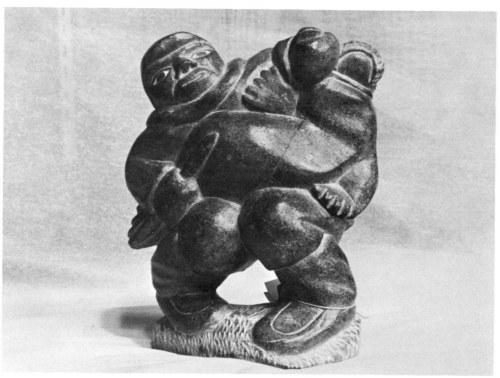

Eskimo sculpture. Courtesy, The Rock Shop, Bar Harbor, Me.

SOFT STONES

The pleasure of working in stone is not confined to the big and brawny, for in spite of the prototype of the sculptor as envisioned in *The Agony and the Ecstasy*, Irving Stone's famous book about Michelangelo, many of the best workers in stone are women. What surprises most people starting to work in stone, is the rapidity with which the concept takes form. The hard stones, such as granite, marble, and so forth, may take a little more time—also specially tempered tools—but working in the softer stones, such as steatite, alabaster, etc., will produce a piece of work with the same lasting quality of satisfacton and creative beauty.

The soft stones most popular for sculpture are the steatites, soapstone and alabaster. For not only do these stones work well in the hands of the sculptor but, when polished, are among the handsomest of sculpture media. The range of colors in the soft stones is tremendous, and the brilliance and the luminosity of the polished stones make them works of art in themselves.

The term "soft" stone should be clarified before we go any further. Stones are classified according to a standard of measuring called Mohs' scale of ten minerals. They are:

1. Talc	6. Orthoclase
2. Gypsum	7. Quartz
3. Calcite	8. Topaz
4. Fluorite	9. Corundum
5. Apatite	10. Diamond

Soapstone and steatite, for instance, are mostly talc, and, as classified in the mineral scale, H1 to H1.5. Alabaster and onyx are about H2 on the Mohs' scale, and so on.

It is really quite simple to scratch or file a piece of stone and you will know by feel how hard it is.

Lava rock, or "feather rock," as it is called, is a volcanic froth, a sponge-like pumice, and so light that it almost floats. It is the balsa wood of the

mineral kingdom. The soft stones that we use in sculpture are mostly:

Alabaster—The color range here is tremendous, from clear to black and white, mottled brown, and white and brown.

Steatite—Also known as soapstone, which runs to the greens, sometimes mottled and sometimes like jade.

Africa Wonderstone—A dark grey to black, and slightly harder than steatite, and, of course, the many variations of stone with local names, such as "Staten Island greenstone," a steatite that is uneven in its hardness and very apt to break while being worked.

GREEN SERPENTINE STONE

by Lorrie Goulet

Green serpentine stone (also referred to as "greenstone") is one of the more interesting softer materials that we sculptors use. It comes in a variety of shades from pale green to dark olive, sometimes with dark veins or mottled patterns of earth colors. It is opaque, semiporous and sometimes quite brittle. It is excellent for the student, as it is easy to carve and presents no special problems.

Let me briefly outline my technique with this stone. Before I begin a piece of green serpentine I examine it carefully for cracks and checks and I remove any loose or crumbling surface material with a claw-tooth chisel. After I have done this I then begin to study the piece and search out its possibilities. My method of sculpting is called "direct carving." That is, I work directly into the stone without using a model or a clay sketch. I draw, using charcoal, directly on the piece to try out different compositions. Most of the time I decide on a general idea and can visualize it completed. Since direct carving is a process of evolving the sculpture, I change and alter the shapes as I work so that, in effect, the finished piece will have grown out of the original idea. I believe every stone has a thousand potentials, and I work with full confidence that I will arrive at a finished piece which is satisfactory and pleasing to me.

Starting the stone, I begin to block out the main shapes and arrangement of the volumes with a medium steel point. As the idea begins to grow clearer, I shift to the claw-toothed chisel or a wood chisel, whichever seems to suit the occasion. Along with these tools I use coarse rasps to help define the shapes. As the removal process continues, and as I near the stage of completely described forms, I use finer rasps and files and remove less and less material. After the sculpture is organized—that is, all the forms, lines and shapes as I want them—I begin to finish the surface. This involves the use of the wet and dry silicon carbide sanding papers. To do this I dip the paper in water while keeping the surface of the stone wet with a sponge, so that the removed material is washed away in the sanding strokes. I begin with the coarse grain of 150 and end with the fine grain

of 600a, using several other number grits in between. When the piece is dry, I obtain a soft luster by buffing it with my hand. Or, should I decide to take the polish further than a satin finish, I use a combination of putty powder and oxalic acid powder applied with a felt pad and worked to a creamy paste with a little water right on the surface of the stone until a high polish comes up. As the stone is porous and the white paste should be removed, I follow this by washing with clear water. Later, when the piece is completely dry, I apply a thin coat of clear paste wax to help seal the pores and to add to the luster.

Unless one happens to want them to show, the whole process of carving the stone, from the blocking out to the finished surface, is one of eliminating the marks of the previous steps so that one would not see, for example, the pits and grooves of the point on the finished surface. I often have a semitextured surface, or the appearance of a casual working technique, as I feel this is such an earthy stone that it should not have a slick look. It is somewhat like music in that the scale of tones, from the rough to the smooth, can be shown. This adds so much to the tactile and visual interest of the finished piece.

Since each stone and each sculpture that I work is uniquely different from any other I have worked before, my approach is a kind of discovery process. The excitement is to find something new, to uncover what was never seen before. In total, the technique and the idea go together. It is never a routine experience, it is always a fresh one and the way in which I carve can have as much variety as the idea I am expressing. It is all a matter of feeling.

Sculpture is done by the hands guided by the mind and the eyes, and green serpentine is such an easy and willing partner in this work that, if treated with imagination and care, fine results can be achieved. This stone cannot be hammered with a heavy hand or in haste, overenthusiasm with the mallet should be avoided. One should never fight with this stone, but rather be friends with it and work it with love and patience. The student will find that, in this way, his skill and creativity will improve and that the experience of learning to know this stone will be a satisfying one, well worth the time and the effort.

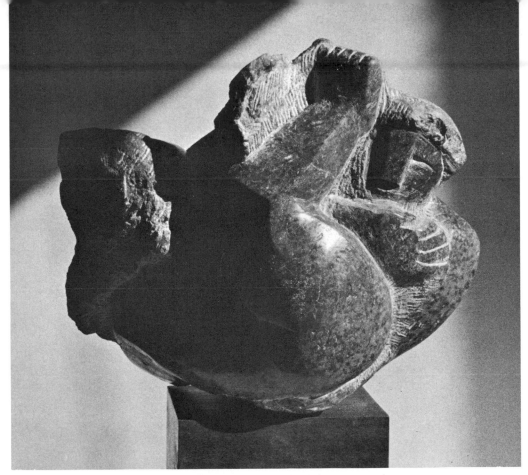

The Game of Love. *Green serpentine stone, 1969. 14" x 12". Private Collection.*

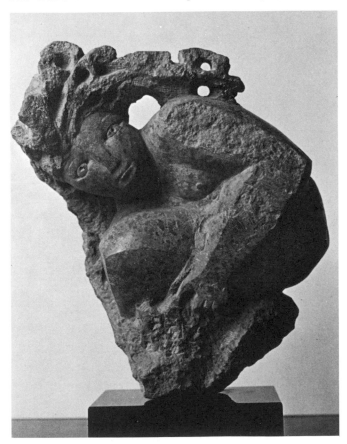

Ariadne. *Green serpentine stone, 1969. 14½" x 10". Artist Collection. Photograph by Bob Hanson.*

127

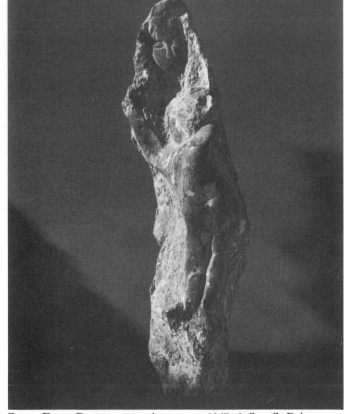

Como Etra. *Green serpentine stone, 1967. 24" x 4". Private Collection. Photograph by Walter Rosenblum.*

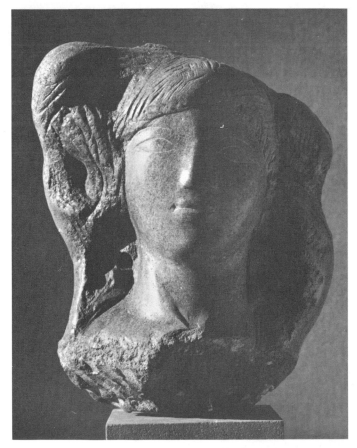

Miranda.
Green serpentine stone, 1966. 14" x 6". Base included. Private Collection. Photograph by Walter Rosenblum.

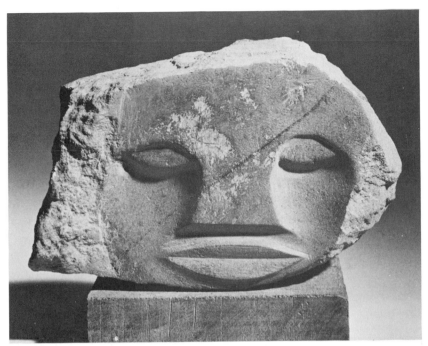

Primitive Head. *Staten Island Greenstone, 10" by Debbie Finch. A first venture in carving by a high school student.*

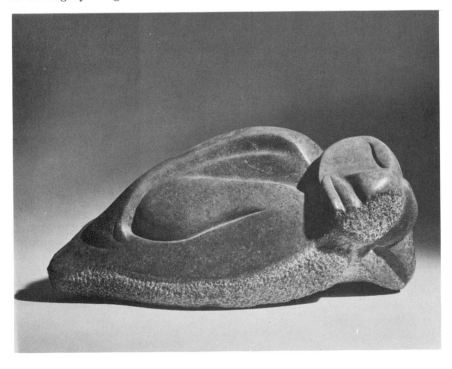

LAVA STONE

There are types of rock that, because of their porosity, are extremely soft and light in weight.

One example of such a stone is lava foam. While rugged and rocklike in appearance, the cellular structure of this rock makes it one of the softest stones known.

Thousands of years ago, when the molten rock flowed and then cooled, the lava became porous and the result was this lightweight stone. One type of this lava rock found in the Sierra Nevada range along the Nevada border has the trade name of Feather Rock, and from its lack of weight, you will find it aptly named. The working qualities of this stone are very much the same as in Styrofoam (which it resembles in both structure and weight). It cuts easily with just a penknife, and crumbles just as easily, not holding a sharp edge very well.

The obvious advantage of this stone is that with only a penknife and a rasp, and (or) sandpaper, one can do a simple piece of sculpture very rapidly. If the concept is broad enough, and done in a simplified manner, the piece could be very interesting.

Illustrated is a piece of Feather Rock that was purchased in a garden-supply shop.

The elephant, done in a broad, simple style, actually took very little time to do. The only real problem involved here was to find the subject to fit the stone.

The grey granitelike color of this rock suggested the elephant, and after that, it was easy.

So, if you can find a piece of this rock in your neighborhood, try it, and have fun!

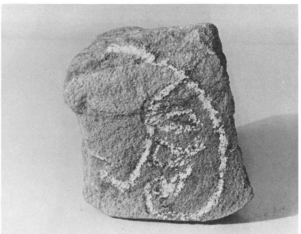

Lava Stone. *This is a piece used with the chapter on "feather rock," or lava stone.*

We draw an elephant's head on our lava stone with chalk.

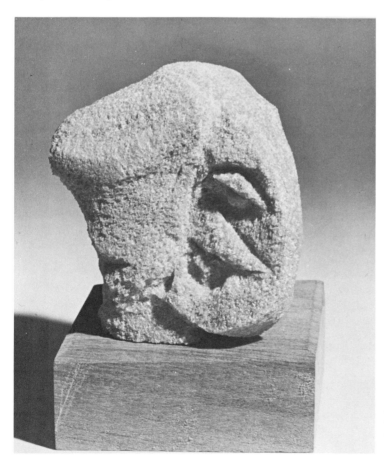

Here is our elephant, cut with first a penknife and then a rasp. You can work this stone in very little time, but it won't polish!

ALABASTER
by Vincent Glinsky

Alabaster, a granular form of the mineral gypsum (chemically, hydrous calcium sulfate), is a slightly translucent material which resembles marble but is much softer. The evaporation of seawater or saline lakes caused beds of gypsum to be deposited in the strata of most geological periods. Gypsum may be found worldwide but the alabaster variety is less common, the largest deposits being found in Italy, England, and the United States, especially Colorado. It is pure white or, because of impurities, pink, yellowish, or brown, often with markings of darker colors, and usually has a pearly luster. The denser varieties can scarcely be distinguished from marble.

Alabaster is easily carved, either with stone- or wood-carving tools. Coarse and fine rasps help shape the masses. Fine sandpaper is used in the final smoothing, and a strong buffing, even a good hand rubbing, will produce a shiny polish. Surface effects may be obtained, as with marble, by using a variety of tools and letting the tool marks stand out in contrast to the more finished areas. Since alabaster, especially the white variety from Italy, is partially translucent, the best subjects for sculpture in this material are those created of simple or massive forms; otherwise, light showing through thinner areas would be disturbing to the overall composition.

A piece of alabaster should be tested for soundness before carving. If tapped with a metal mallet, a dull thud rather than a ringing sound will indicate a crack or fracture. In this case a large rasp should be used in the blocking-out process, rather than stone chisels which might shatter the material. Sponging the piece with water will bring out the veining more prominently so that the sculpture may be adapted to the markings. The color, veining, and general shape help determine a subject. I have found a good deal of pleasure in carving, finishing, and bringing out the hidden beauty of alabaster.

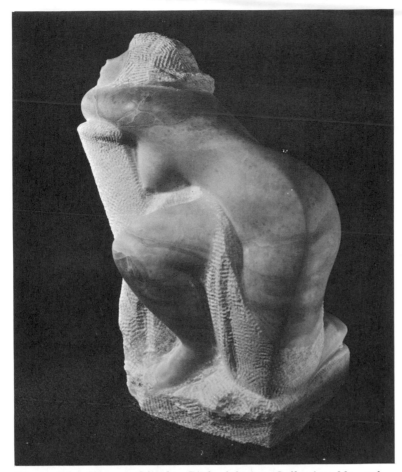

Dreams, *by Vincent Glinsky. Pink alabaster. Collection Mr. and Mrs. Kesterbaum. Photograph by Soichi Sunami.*

Bather, *by Vincent Glinsky. Himalaya cream colored alabaster with various tones, 8" high. Private Collection, Canada. Photograph by Soichi Sunami.*

133

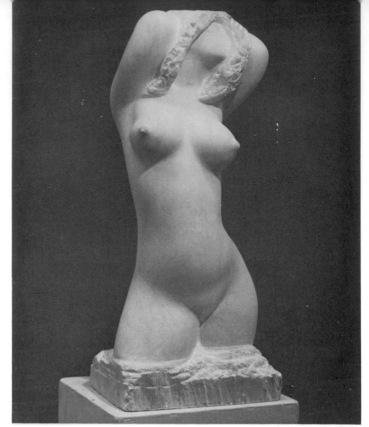

The Bather, *by Vincent Glinsky. Alabaster, 25" high, 10" wide, 8" deep. Photograph by Walter Russell.*

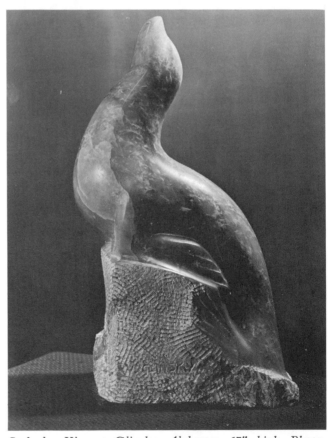

134 Seal, *by Vincent Glinsky. Alabaster, 17" high. Photograph by Soichi Sunami.*

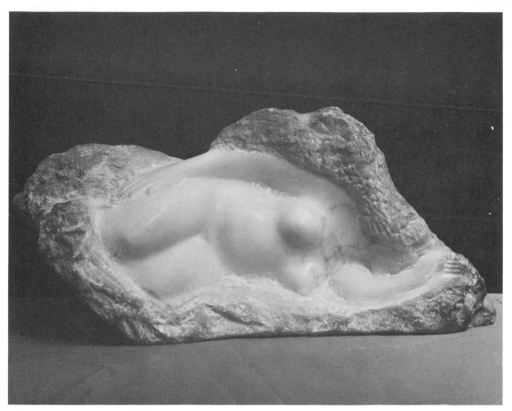

The Dreamer, *by Vincent Glinsky. Pink Alabaster, 12" x 6" high. Photograph by Walter Russell.*

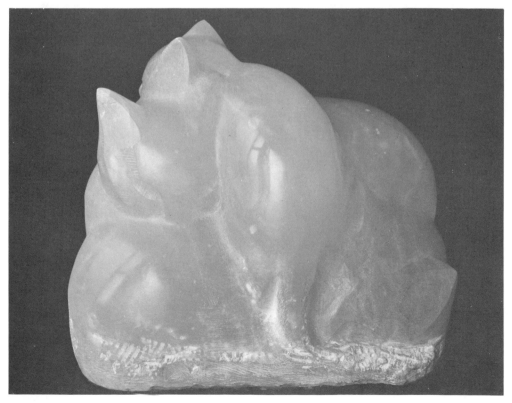

Napoleon and Family, *by Vincent Glinsky. Italian white alabaster, 12" high. Private Collection. Photograph by Walter Russell.*

GYPSUM ROCK

by Benedict Tatti

Gypsum rock is a mineral which is a coarse variety of alabaster. It may be veined, opaque or semiopaque. This material (rated $2\frac{1}{2}$ on Mohs' scale of hardness) can be scratched with a knife. Gypsum rock is referred to as hydrated sulfate of lime or hydrated calcium sulfate and has a chemical designation of $CaSO_4 \cdot 2H_2O$. It is generally mined or quarried, and is found in sedimentary deposits associated with limestone, shale, clay and sandstone. Coloration is caused by its oxide content.

Large deposits occur in New York State, Michigan, Texas, California, Iowa, New Mexico and Colorado. In industry it is used for a retarder in cement and a flux in glass. The veined and coarse gypsum rock, when heated and calcined, is mainly used for the manufacture of plaster of paris.

Because of its similarity to marble, the material is equally suitable for execution of small-sculpture models preliminary to the larger work, as well as for a final work of art in itself. It is soft, easily carved and takes an excellent finish. For these reasons, I frequently use gypsum rock as a design medium.

My initial preparation to carving entails the selection of a solid rock specimen. Striking the material with a small, metal hammer should produce a ringing sound (a thud indicates an internal crack or flaw). Wetting the stone thoroughly allows fissures to become visible. Gypsum rock may have areas of sand-impregnated veins that will crumble. These should be avoided.

If the selected piece is too light in weight to sustain a blow from the sculptor's mallet, affix it to a heavier stone. I often use burlap ties dipped in plaster of paris to anchor the base of the carving material to a heavier stone.

The next step requires drawing the design on the stone with a black felt-tipped pen.

All sides of the carving material should be outlined. Darken the areas to be carved away. For the carving procedure, carpenters' woodworking

gauges, chisels and a lightweight mallet are necessary. Regular metal stone-carving tools would bruise this soft substance.

Block and rough out forms with gauges. Clarify the forms with straight flat chisels. Details are accomplished using veiners and fluter chisels. Files, rasps and rifflers further define the form. Wet and dry abrasive papers 200–400 and 600 grits are the finishing materials.

The final polish is achieved by hand rubbing with a paste of rottenstone and tin oxide. A light oil applied to the surface will enhance the inherent color, and a coating of clear paste wax will protect it.

Soapstone reliefs. These were carved from pieces of a broken soapstone sink by B. Tattis' high school students.

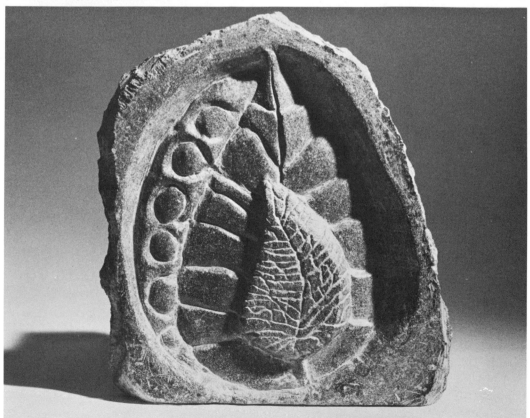

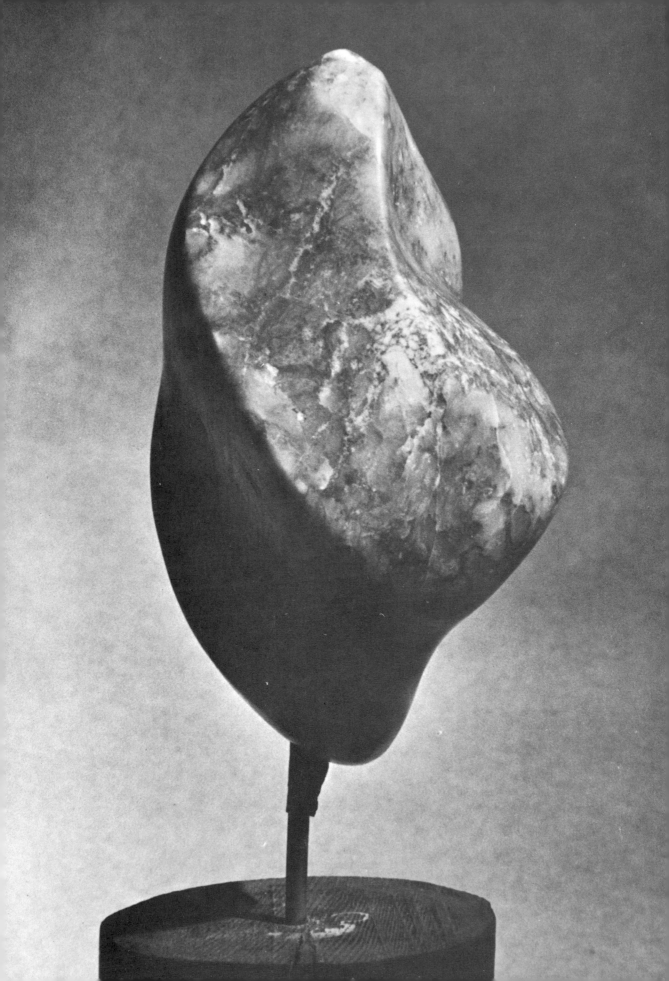

Basic Tools for Slate and Stone Carvings...Their Uses and Necessity

(all other tools optional)

Chalk
Scriber or Awl
Screwdriver
Flat Chisel
Hammer

Bush Hammer
 (for stone but not slate)
Rasps or Rifflers
Sandpaper or Emery Cloth (wet or dry sandpaper)
Clamps

Rottenstone
Wax
Toothed Chisel
 or Toothed Screwdriver
Steel Wool
Goggles

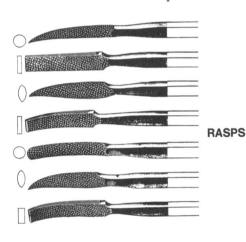

RASPS

BUSH HAMMER

STONE CARVERS HAMMER

UNIVERSAL BUSH HAMMER

BENCH CLAMP

CHISEL **TOOTHED CHISEL**

Some of the less familiar, as well as less available, tools used in stone sculpture.

Some Sources
of Supply

Tools for Slate and Stone

The Craftool Company, Woodbridge, N.J. 07075.
Sculpture Associates, Ltd., 114 East 25th Street, New York, N.Y. 10010.
Sculpture House, Inc., 38 East 30th Street, New York, N.Y. 10016.

Stone

Sculpture Associates, Ltd. (alabaster, steatite, marble, etc.).
Sculpture House, Inc. (steatite, alabaster, etc.).
Stewart Clay Company, Inc. (soapstone), 133 Mulberry Street, New York, N.Y. 10013.
Friedman Marble and Slate Works, Inc., 37–21 Vernon Boulevard, Long Island City, N.Y. 11101.
Alabaster Supply Company, 1903 High Place, Santa Monica, Cal. 90404.

Slate

Domestic Marble and Stone Corporation, 41 East 42nd Street, New York, N.Y. 10017.
N.Y. Blackboard, Inc., 139 Spring Street, New York, N.Y. 10012.
Valley Marble and Slate Company, 463 Danbury Road, New Milford, Conn. 06776.

FRANK ELISCU

was born in New York City in 1912 and attended the Beaux Arts Institute of Design and Pratt Institute. He was later apprenticed to Rudolph Evans and has made numerous designs for Steuben Glass and executed a great many architectural commissions, both public and private. He is an academician of the National Academy of Design. He is also past president of the National Sculpture Society.

Mr. Eliscu has won many honors and awards. Among his recent commissions have been *St. Christopher*, for the St. Christopher Chapel, New York City; *The Charger*, Dallas, Texas; *The God*, New York Bank, New York City; *The Torah*, Temple Sinai, Tenafly, New Jersey; *Abraham Lincoln*, Lincoln Bank, New York City; *The Naiad*, 100 Church Street, New York City; and *Man and the Atom*, Ventura, California. His *Shark Diver* is in the magnificent Brookgreen Gardens in South Carolina and he is also the creator of the famous Heisman Memorial Trophy, better known as the All-American Football Trophy. One of his latest triumphs is a three-figure sculpture of *The Astronauts* at the Headley Museum, Lexington, Kentucky.

He has just completed *The Story Hour* for the Santa Paula Library, Santa Paula, California.